It's All About the Memories

Preserving your precious memories
for future generations

Gretchen M. Fatouros

Photo Keepsake SpecialistSM and Professional Organizer

Cover design by Soucier Design in Fairport, NY

Contact information:
P.O. Box 426
Churchville, NY 14428
Gretchen@FromClutterToWOW.com

It's All About the Memories
ISBN-13: 978-1466316485
ISBN-10: 1466316489
Library of Congress Control Number: 2011917078

First edition: November 2011

All stories written in this book are true, although the actual names have been changed.

To my family Pete, Peter and Alex.

You bring out the best in me.

TABLE OF CONTENTS

ACKNOWLEDGMENTS

Thank you to my family for their understanding and patience.

Thank you to:

- **Joani Hardy** for pointing out to me that I am a "photo expert". It's interesting how easy it is for us not to realize our own talents and strengths.
- Amazing proof-readers and editors! I could not have done this without you! **Joetta Tucker, Kim Miller, Barb Tinch, Prartho Sereno, Peter Fatouros, Alexander Fatouros, Robyn Francis,** and **Karl Heberger**.
- The final critical eye: **Joetta Tucker!** I couldn't have finished without you!
- For answering questions and helping me assure a complete book: **Leah Crosman** and **Ginene Heberger**.
- Online backup systems and current computer knowledge: **Karl Heberger**
- Retired librarian, **Gloria Morris**, for all the book knowledge.
- **Grant Heberger** for introducing me to a dye-sublimation photo printer.
- **Barb Karl, Lisa Brockway,** and **Nancy Mancuso** for introducing me to scrapbooking, which lead to the absorption of the information in this book.
- **Prartho Sereno, Suzanne Driscoll,** and **Rachel Doll** for publishing advice.
- **Lissanne Oliver** for book advice including the Index.
- Shawn, at Staples, for the best current information on digital storage options.
- Two extremely knowledgeable women at the Wal-Mart in Brockport, NY, in regards to printing methods.
- All the countless people I asked "on the street" how they handle their photos.

Thank you so much to the following families for sharing their photos for the cover design: **Copeland, Crosman, Emery, Fatouros, Heberger, Miller,** and **Tucker.**

And an additional cover photo with **Linda Birkinbine.**

Subtitle by Andrew Soucier of Soucier Design.

Thank you for sharing pictures used inside this book:

- Lindsay Kerry
- Mindy Wallington
- Robyn Francis

1: EVERY PICTURE TELLS A STORY

"A picture is worth a thousand words."

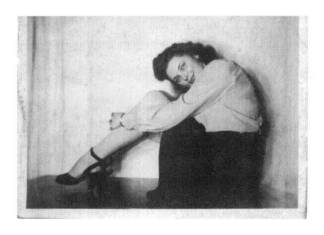

When you look at this photo, what do you see?

If this were a member of your family, would you know anything about this picture? What does it say to you?

I found this picture after my Grandma Dorothy passed away. I don't recall how or where I found it, but I remember thinking that this is the youngest I've ever seen my grandmother.

I found it too late to ask my grandmother any questions. I would like to know: When was it taken? Why? Where? Who took the picture? Those questions will continue to bother me because there's no way of finding out – Grandma is no longer with us. That story died with her.

I wish I'd considered asking questions to understand more about my grandmother's life. What was it like living during the Great Depression? What types of hardships did they endure? What about WWII? I might be able to ask my parents some questions. I would love to know more about this wonderful lady! She was one of the most important people in my life. Yet when I look at this picture, I think, "There was so much I did not know about her!"

Although they say that a picture is worth a thousand words, what is a picture worth if the memories are lost? The picture of my grandmother is an example of all the stories that I've lost simply because I didn't think to ask.

ఞఞ ఞఞ ఞఞ ఞఞ ఞఞ ఞఞ ఞఞ ఞఞ

What is the legacy you are leaving to the next generation? Don't just be a name on a family tree. Share the story of your life, so it can be enjoyed by your children and grandchildren! You should be writing down your own history. Your kids, grandkids and possibly your great-great-grandchildren will want to know the story of your life. What was everyday life like in this century? Where did you go shopping? How much was a loaf of bread or a gallon of gasoline? What was your home like? How did you spend your time outside of work? What did you do for a living?

How did the major events of the time affect you? How did you feel, react, and hear about famous parts of history? What changed your life forever? Think back to the events you have already experienced during your lifetime: when John F. Kennedy was assassinated, the moment the first plane hit the twin towers, or when the first black president was elected.

Don't let this history die with you – write it down and tell your story!

If you don't believe that anyone would really care about what you have to say, or be interested in your memories, just look at the books and movies that portray life in the past – we are fascinated by them. Turn on PBS or the History Channel and look at the number of shows that bring the life of someone in history right into your home. Browse websites like History.com, and consider the growing popularity of genealogy websites. Look at the history section at your local library or book store and you will find a few popular books you are probably familiar with, like the Little House on the Prairie series and The Diary of Anne Frank. The authors were not famous people when they were alive; they were average, every-day people living in a unique period in history. They became famous because they offered the rest of us a personal glimpse into their lives by simply writing it down.

Enough talk for a moment, let's play a game.

Find a picture – perhaps you have one right in front of you on a desk, on your cell phone, in your digital camera, near the bed, on the wall, or in your wallet. Use this one because obviously it's important enough to keep where you can easily access it and enjoy its memories.

What do you think about when you see this picture?

- The people?
- What was going on when the picture was taken?
- The location, the weather, or the season?
- Was it a special event or just a day in your life that someone happened to capture at a random moment?
- If this person is no longer with you, does this photo remind you of special memories with them?
- Perhaps their smile?
- Your favorite activities with them?
- Special holidays and other special times shared?

Feelings are a significant part of the memories. Our feelings confirm an emotional connection to the person, place, or things in the picture. If you showed this same picture to a stranger, they wouldn't see the same things you do, because they don't know the background story. They do not share the memories, and would therefore have no feelings associated with the picture. Another person would just see the physical picture and the objects in it – not the connections to friends and family.

> The feelings are part of the memory and are held in the person who has an emotional connection to the person, place, or things in the picture.

Remember to tell the stories of your pictures; write down the important parts of your life. Even if it's just notes on a calendar or on the back of a photo, it's better than writing nothing at all. This will help you remember more details about your photos.

Give your memories a place of honor not only in your heart, but in your home.

2: PREPARE

"Before anything else, preparation is the key to success."
~ Alexander Graham Bell

This chapter will prepare you to take the next steps in your photo-organizing journey.

Some Basic Steps to Get You Going...

When you organize, there are some basic steps you will follow:

- Choose where to start (goals).
- Schedule time to work.
- Set up a location to work.
- Remove everything from the area you are working (do not take out more than you can do in your allotted time).

 Example: one drawer or shelf at a time.

> Contain like items together (consider drawer dividers, baggies, and bins)

- Discard trash and items to recycle.
- Sort like items together.
- Contain like items together (consider drawer dividers, baggies, and bins).

- Return items to where they belong.
- Keep it up; maintain it.
- If needed, ask for help.

When it comes to items that belong in other areas, have a large basket (or make a small pile) to put these items, so you will not need to keep leaving the area you are working in. Stay focused on the task at hand. When you are done with the organizing, you may then pick up the basket or pile and put those items away.

Depending on the amount of random items you find, that do not belong in the area you are working in, you might want to have a pile or basket for each additional room, area (i.e. upstairs and downstairs), person, etc.

Create a Plan

When you get into your car, do you plan where you are going ahead of time? Do you map out the path you'd take to get there? If you drove around, was it just for enjoyment?

With the price of gas being so high, you will save money as well as time by planning ahead. You need to decide your destination, or goal, before you can begin. How else will you know when you are finished?

It may take a little time and thought to come up with a plan, but you will be so glad you took this step to get the finished results that you desire. Even if it's just a way to enjoy the scenery along the way, at least you have a plan!

૭ૹ ૭ૹ ૭ૹ ૭ૹ ૭ૹ ૭ૹ ૭ૹ ૭ૹ

If you could wave a magic wand, what would you see? Completed photo albums for every member of your family? Framed pictures around your home? Organized pictures that can be easily found? Album or slide-show for a high school graduate? Baby album? Pictures available to grab in case of emergency?

Now, realistically, what do you really want to do with your photos? What's important? Why? What will you look at again?

Start Where You Are

For things that continue to pile up regularly like mail and photographs, start with today. When you are caught up, and have things under control, then go back to older items. Of course, if you desperately need something now (like a bill to pay), go find it.

> You should start where you are now, and eventually you can go back to the older stuff.

The reason behind this is that life continues to happen whether we want it to or not. If you start with today, it will be easier to recall the details behind an item or picture.

For example, the picture of your son in front of his cake with his fingers in his ears - you'll know the story firsthand.

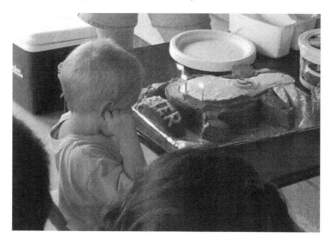

You can write about the event, so it stays in your memory long after. You can write about the things you'd like to remember in the future (remember that picture of my grandmother in Chapter 1).

- When was it taken?
- Why?
- Where?
- Who took the picture?
- Why were his fingers in his ears?

- Who made the cake?
- What was the cake's design and why?
- Who helped celebrate?
- What was the day like?
- Any special memories from that day which only a parent would remember?

If that was your birthday, what do you wish someone had remembered to encapsulate?

Everyone has their preferred way of doing things. You can follow any steps you would like. It's just recommended that you start with now -- today, this week, this month, or this year. You will know enough about these memory triggers to recognize how to store them simply. Remember why they're important, and write about their importance.

Staying current as you go, prevents you from getting further behind.

Be Realistic With Yourself

During my years of helping people become more organized, I've met many who feel paralyzed by everything they want to accomplish. They don't know where to start, and often find it too difficult to even begin.

They may have been unrealistic and set their goals too high. It may be too overwhelming for them to tackle on their own. There may be an underlying feeling of "why bother?" if it can't be done perfectly.

The goal of this book is to give you the steps to get you started. Even if it's just a small step, it will get you further than you were yesterday. Do not expect to wave a magic wand and find all your pictures, memorabilia and stories in beautiful scrapbooks. It's not realistic. Instead, focus on what you can complete today to make sure your special memories are not lost tomorrow.

> Focus on what you can do today to make sure your special memories are not lost tomorrow.

8

The steps in this book are recommendations to guide you along and keep you moving forward.

"Do my photos have to be all sorted, labeled, and stored perfectly?" NO! It's just essential that they be stored in a safe environment. It's okay if you don't get to everything! You are only one person. Starting anywhere will get you further than where you are now.

Taking a picture, or writing about where you are today, will help motivate you along the way and help you view your progress. Begin performing steps in this book and then take a new picture or note to show where you are now. You'll be able to see the progress, which will motivate you to keep moving forward.

Make an Appointment with Yourself

Have you ever had a gym membership? Did you use it? If you did, it was probably because you set aside time for yourself. You made a schedule and stuck to it. Like the gym membership, invest in your life – preserve your memories.

Organizing can be something that people do not really want to do, similar to working out. If you do not schedule it into your day, you will constantly find something better to do. "When I have time" will never really happen. While you are procrastinating, the pictures will continue to pile up.

Schedule time into your calendar to organize your pictures and memorabilia. You can use the spare moments you have throughout the day. Get up earlier, or block off specific time to work. I suggest making an appointment with yourself by writing the appointment on your calendar; otherwise, it's easy to put it off until tomorrow.

To get started, you do not have to schedule an entire day. Sometimes, like when you start working out, it's best to start in smaller increments. This is where I love to bring out my timer! I will set it for 15 minutes if I only have about 20 minutes of free time. This gives me time to get started on the project, and leaves me enough time to clean up after the alarm goes off. If you think you will need more time for clean-up, factor that into your time.

Work in Small Amounts

Keep in mind that you do not want to pull out more than you can organize and put away at one time. Example: if you are interested in organizing your kitchen, you would not pull items out of every cupboard before

> Do not stop until you've put everything away!

getting started. That would require your allotted 20 minutes or more to accomplish. Then that does not leave you much time to get anything else done, like preparing dinner in the evening.

The best way, in this example, is to work on one cupboard or drawer at a time. Pull everything out, keep only the things you love or use, discard trash, sort like items together, and only return items which belong in the drawer or cupboard. The remaining items need to be put away where they belong. Do not stop until you've put everything away!

For example, if you find a pair of socks in the kitchen, we know they do not belong there. Instead of putting them back into the kitchen drawer, depending on their level of cleanliness, they should be placed in a dresser or laundry basket.

Make Rules to Stay Organized

After all the work you've done to get organized, you do not want to go back to where you started! In order to keep it up, you will need to set rules for yourself. Organizing rules you may have heard before include (but are not limited to):

- "One in, one out" – every time you bring something new into your home, you should remove something older that you are no longer using. Many times you are bringing something in to replace an item that is older or broken. Remove the older item now before you forget, and it piles up with other older items you no longer use.

- "If I have not used it in the last 6 months, it should be removed from my home." I usually say 6 months to a year. The reason for this is that some items are only used once a year for holidays or other special occasions. If you use it, it

can stay.

- "If I do not use it or love it, it goes!" I highly recommend only keeping those items which you love or use! You want your home to be a reflection of yourself. If you do not love what's around you, it will not help you to be the best you can be! If you don't love it and don't use it, then why do you have it? Why are you letting it take up your space? Give it away and bless someone else with it.

You will find examples of maintenance in chapter 7.

Ask For Help

Sometimes it's difficult to get started or difficult to get the motivation to continue on. You might even feel like you lack some of the basic skills to begin.

It's okay to ask for help. Friends, relatives, or a Professional Organizer can help. You do not have to do it alone! Why do you think there are trainers out there for physical fitness? They can show you how to perform the exercises, teach you how to do it yourself, and provide both motivation and accountability along the way.

You do not have to do it alone!

A friend or Professional Organizer can do the same for you and your memories.

3: GATHER

If everything is important, you lose focus on what's truly important.

It's now time to get working with our memories (pictures and other memorabilia you've collected over the years)! Hopefully, now you understand why it's important to give yourself the time to work on honoring your memories.

The first part of preserving your memories is gathering them all in one place. It's one of the basic organizing principles – put like things together. By having a home for all your memories, you will be able to enjoy them more! By collecting them all in one place, you will also know how much you have. Then you will be able to figure out the best way to store everything, because you will know what you have and will have a plan for how to sort it.

Prepare to Work

Before you get started, set aside some time and choose a good spot to work. It will need to be a place that can hold all of the items you are collecting. This can be a temporary location, like a dining room table, or a more permanent location like a guest bedroom or closet.

For this part, a table or other flat surface will help corral your

photos and memorabilia.

You will also want garbage and recycling bins available while you work. As you collect memories, you can begin doing a little bit of presorting. Don't worry about doing too much, because we'll be covering sorting in the next chapter.

Gather the Good Memories

You can easily toss blurry pictures as well as all of those that were accidentally taken, unflattering, and mistakenly printed. Those would include a foot, part of the floor, etc. It happens to all of us. If there is a delay, you might move the camera before the picture has been captured. Maybe it turned itself on in your purse, or a child took some pictures for you. Unintentionally printing the "oops" photos is not a reason to keep them. Let them go and forget about the few cents you wasted. We're only saving the memories here.

 I think I'll toss this one.

You do not have to get everything together all at once. You can start with this month's pictures: collect, sort, write about, and store. Then you can move onto older pictures. When working this way, make sure to leave room within your storage solution for more pictures as you continue to gather, sort, and store.

You can also gather the pictures that you find as you are doing other things around the house. We often find pictures stashed and long forgotten about. Collect them all in one place now, so you can find them when you are ready to begin sorting and storing them properly.

Things to collect photos, negatives, small memorabilia that you are not using (if it's a T-shirt you wear, you do not need to add it here unless you take a picture of it to add to the memories being col-

lected), digital photo files: digital photo discs[1], memory cards, USB flash drives, hard drives, etc.

When it comes to collecting pictures, I will share two different ways that this can be done. One way will be for physical stuff including pictures and negatives. Another way will be for those digital photo files which can be just about anywhere on the Internet and in your electronic devices.

If you are like many of us, you may have a slight overlap between film and digital images. I kept my 35mm film camera for several months after we had purchased our first digital camera. When I looked for a specific picture of my sons meeting for the first time, I forgot that it was a film picture (with negatives) and not a digital photo file. It took me a while to find it. Since then, I prefer to keep all my images (prints, negatives and digital photo discs) in chronological order. This overlap will mean you have some digital photo discs, along with negatives and printed pictures.

The main thing is to do what's right for you! We'll talk more about sorting / organizing the pictures in the next chapter.

Physical Pictures, Negatives, Memorabilia

Beginning with physical pictures, negatives, and memorabilia is a great place to start since this will be the easiest to collect. It's already available. Make sure you find everything. Remember to check the basement, attic, picture frames around the house, Rubbermaid totes, sock drawers, and other locations you may have stashed pictures: including old photo albums and family Bibles. Consider doing a sweep from room to room throughout the house to make sure you didn't miss anything. Check drawers, under the bed, etc. You can ask friends and family. Although you might not have those pictures from your first birthday, I bet your mom does. If you have duplicates from when you went on a trip with friends, share them. Your friends might appreciate being given a memory.

Once you have the physical items, put them in your pile for

[1] When I use the term disc, I'm referring to CDs and DVDs.

the next step (sorting). You can begin doing some basic sorting as you collect pictures. You can sort pictures into piles depending upon years, child, vacation, etc. We'll talk more about this in the next chapter (Feel free to skip ahead if you'd like).

If you find unprocessed rolls of film, get them developed. You do not want to wait too long on this step. The longer you wait, the more difficult it will be to remember what you photographed. Undeveloped film is much more susceptible to light and can be ruined easily. When the pictures are printed, you can sort them.

If you scrapbook, this is good time to pull all those scrapbooking supplies out. If you purchased stickers to go along with specific pictures that you have, store them with the coordinating pictures and memorabilia. You will want to have those scrapbooking supplies together and near your memories for that step later.

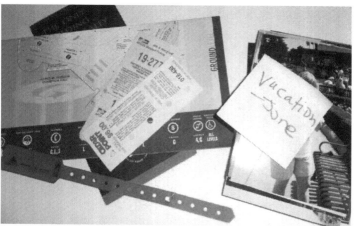

Collecting vacation items, along with pictures. Don't forget the ticket stubs, park bracelet, maps, and other items you've saved.

Start to journal as you sort your pictures. You can write notes on paper or talk into a recorder. As you find different pictures and other memorabilia, they'll probably bring back memories (similar to what I talked about in chapter 1). When those thoughts are still fresh in your mind is a great time to begin

writing. Write about who, what, where, when, and why. Also,

Write about the other feelings and memories that come up like the smell of the ocean, the overall enjoyment of the trip, the special meaning of that specific location or item. You can also write on the backs of photos as long as you write with something made specifically for this. Please do not use a pen as many of them hurt photos due to acid or other harmful chemicals in the ink. You can also harm your photos from the pressure of writing on the back of them. Instead, use a photo pencil which is designed to write on the backs of pictures or other photo safe pen, such as a sharpie (which will not leave indentations in your photo). You can also use photo safe paper with the pictures. As you find negatives, remember to label them, too.

Collecting and sorting is a great activity to do as a family! You will get everyone's stories and have fun reliving the memories.

> Collecting and sorting is a great activity to do as a family! You will get everyone's stories and have fun reliving the memories.

Consider taking a few pictures to accompany you during appointments. You can write about them while you wait.

When it comes to collecting items and sorting them, remember to be selective. You cannot keep every piece of baby clothing (unless you plan to have more kids) – there is not enough room, and it will keep the extra-special pieces from being just that: special.

The same is true of the pictures. Keep the best of the best and write down the stories that make it even more memorable.

When you and your family look back at the pictures, stories and items you've collected, they will have greater meaning.

Your children will be able to relive events from the past, look back at their own childhood to better understand their own children, and be continually reminded of how much they are loved.

Salvage Photos from Old Albums and Frames

As you are saving pictures, you may realize that you have some old photo albums which are desperately holding onto your special memories. Many of the sticky album s (sometimes referred to as **"magnetic** albums"), that were popular in the 1980s, can be so sticky that it can be next to impossible to remove pictures from their pages.

Over time, pictures may stick to the glass of their frame. It's usually caused by moisture.

The most important thing I want you to keep in mind is: do not force your pictures away from the extra-sticky page or frame. This could ruin them.

> Do not force your pictures away from the extra-sticky page or frame.

Instead, I suggest scanning the picture on your home computer or at a local store. Many stores offer kiosks which will let you scan in photos. If the picture in question is copy written (like a professional picture), you may not be able to scan in and reprint it from a store. Ask the employee in the photo area what they suggest to salvage the picture in question. Many stores will be able to offer other options for you. You can also ask friends and family with scanners to help you.

When scanning in photos, make sure your image comes out clearly

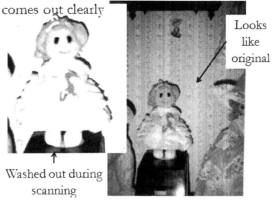

Looks like original

Washed out during scanning

Once your picture has been scanned, then you can attempt to remove the photo from the album or frame. With a little patience, sometimes pictures can be removed without damage.

I suggest trying a Multipurpose tool (from Creative Memories) or dental floss. I personally had better luck with the Multipurpose tool. However, some pictures may be too stubborn to remove without damaging them.

Once you've removed your photo from the album or frame, make sure to remove any additional adhesive or other substances. These particles can continue to damage your photo.

If the picture is damaged, print the scanned copy. Save the digital photo file with your other digital photo files.

Digital Photo Files

When looking for your digital images, do not forget to check all of your electronic devices. Remember to check your camera (s), phone, disc, external hard drives, on your computer's hard drives (remember all of your computers), USB flash drives, and memory cards. If you have online accounts where you've shared and/or printed pictures, remember to look there, too.

When it comes to digital photo files, you will be using your computer to sort. It may help to put all your digital photo files in one place. Photo boxes and books for storing CDs work great for keeping all your discs in one place. If you have items in other locations, keep those links and physical items by your computer, so you can easily find them as you begin the sorting process.

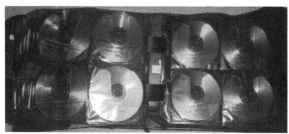

CD book that holds 8 discs per page.

Discs in a photo box - some in sleeves and some in CD jewel cases. Don't stack discs, so they won't get scratched and become unreadable.

Before doing any sorting, please make at least one extra copy of all your digital photo files. You always want to be sure to have at least two copies when you are talking about electronic data because computers, and all the other devices we store digital photo files, can crash. You could lose everything.

4: SORT

*"Your photographs reveal how you see things and
what you think is important."*
~ Jeanne Wines-Reed & Joan Wines
(Authors of: Scrapbooking For Dummies)

Now that all your pictures and memorabilia are in one place (chapter 3), let's sort them, so you know where to find photos and memories when you want them. When your child's kindergarten teacher asks you to send in a baby picture, you will be able to find it easily.

If you are unable to sort now, please read chapter 6, so you can store your photos, negatives, and digital photo files in a <u>safe</u> location! Also review chapter 5, and remember to write about your memories.

Now that you are ready to get started (even if it's just a little bit here-and-there), let's think about what our goal is.

Set Goals

How do you want to enjoy your pictures and memories? In an album like a scrapbook? Digital photo books? In frames? In photo boxes? On the computer?

Once you know your final vision, you can easily sort pictures and

memorabilia into like groups.

You do not need to have the same goal for all your photos and memorabilia. For example, you could keep all the special greeting cards sorted by child, specific pictures or most recent pictures in frames and albums, depending on the type of photos – online photo book using digital photo images and a traditional album for older (printed) photos. Do you want to sort by child, vacation, years, seasons, and holidays?

The possibilities are as endless and unique as you are! It helps if you already have a plan on what your end goal is.

☙❧ ☙❧ ☙❧ ☙❧ ☙❧ ☙❧ ☙❧ ☙❧

Ask yourself some questions – feel free to write them here or on other paper.

I take pictures because: _____

Keeping this reason in mind, my overall goals for my photos are to:

My current pictures are (location): _____

I would like to:

_____ with my current pictures.

_____ with my digital photo images.

_____ with my printed photos.

_____ with my negatives.

_____ with my greeting cards.

_____ with my postcards.

_____ with my other memorabilia.

I would like to print these types of pictures _____

How I would prefer to enjoy and store photos and memorabilia:

Now, go back and take a look at your answers. Are they realistic? For example: If you want to get all of your pictures into albums, will you be able to set aside the time for this? Is there an alternate location you can store these memories before they go into an album?

I hope this helps you get started on understanding your own goals.

Purge Bad Pictures and Memories

As you are going through your items, make sure you sort into logical piles and remove items that do not need to be kept. Blurry, dark, and unflattering pictures are the easiest to part with. Toss them right away. Doing this during the collecting stage is really the

A fuzzy picture will not get any less fuzzy.

best time. You already know they're no good and should not waste any more time looking at these pictures. All they'll do is take up valuable space that can be used for good pictures, and waste time each time you need to look for something.

I'm going to guess that most of the things you have kept will be from good memories. If something brings back a bad memory, why are we holding onto it? Is it too painful to let go? Are we trying to hold onto the past? Unsure how to let go? Feel guilty for considering letting it go? Trust me it's better to let it go than hold onto it and continue to feel those negative thoughts.

Example:

A client, Sara, had an embroidered piece with her name and her husband's and their wedding date on it. Sara and Sam had been married for over thirty years, and yet they never got around to framing or displaying this beautiful piece.

As we talked more, we realized that this well-crafted keepsake brought back terrible memories about the person who made it.

There was a lot of guilt involved for not putting up this keepsake after this friend had worked so hard on it. This was evident when we found it with a frame. It was ready to be assembled and simply placed on the wall.

Sara confided that this friend had committed suicide, and that's what she remembered every time she looked at this beautiful piece.

In the end, they realized they had to part with it. Sara and Sam decided that the best way to honor their friend was to have a burning ceremony for this embroidery.

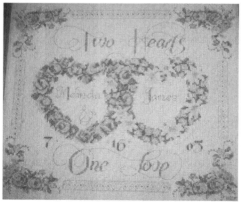

Example of wedding embroidery

If you are holding onto things you shouldn't, it's okay to let go. You will feel so much better when you do. Depending on the item, you might be able to let someone else enjoy it!

Part of sorting includes getting rid of bad photos. A fuzzy picture will not get any less fuzzy. Pictures of your feet or other accidental pictures do not need to be kept either.

You might want to look at your collection of landscape and panoramic photos that were fun to capture during vacation. When you get back, do you remember why you took them? Do they really have a special meaning or will they mean anything to future generations? Yes, some may be really great to keep. If you'd taken a picture in New York City before 9/11, it would be great to see that sky line again. If they have historical significance or are well labeled, they will mean a lot more to you and your family in the future. Keep this in mind when deciding which pictures to keep.

Duplicates are also okay to remove. If you receive double prints, you can toss the second set of pictures, or give them to someone who might enjoy them, like a grandparent or child. If you continue to get double prints, ask yourself if you really use them or not. If not, you are not saving anything by printing each picture twice.

I'm sure you're guilty of this, too —not wanting to miss out on the excitement of a moment, you find yourself snapping away. When you get your pictures back or check your memory card, you realize you've taken dozens of pictures (or an entire roll of film) for one event or moment. The pictures are either almost identical or a progression of events.

You should only keep a few of the best pictures to help retell the story.

Whatever the reason and the type of pictures, you should only keep a few of the best pictures to help retell the story.

Example:

I would take pictures every month of my son for a wall frame. The frame had openings for each month.

I knew this day would never happen again, so I would easily use a full roll of film to assure the perfect picture.

Once I decided which photos belonged in each of the monthly holes, it was okay to get rid of the other ones. There are many where his eyes are closed, or where he isn't looking right at me. I can also toss the ones that are so similar, because this one is better than that one.

I admit it takes some getting used to, and I'm not perfect at this, yet.

Monthly growth of my son.

By choosing the best pictures, I create more space for new memories. I will no longer need to view the bad ones in order to get to the good ones. Speaking of bad pictures - we've all had unflattering pictures taken of us. Get rid of them now. Who wants to be remembered like that?

If you keep everything, you lose focus on what's truly important.

Limit what you keep or someone else will have to do it later. For example, you have old love letters, journals, or other things that you do not really want your spouse or

> If you keep everything, you lose focus on what is truly important.

children to see. Get rid of them now. It may be fun to have a bonfire with friends, tossing out those old memories that do not fit your current life. Think about what you want to remember and how you want to be remembered. It can be a fun purging event!

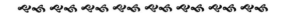

If you still need a little more help deciding on some of those items and pictures, here are some questions to ask yourself as you go:

What is most important to me? _____

 Is this item one of those things? Yes / No

 Do I have others that are similar? Yes / No

 Am I keeping only the best? Yes / No

What memories are important in helping me define who I am?

 Does this photo or item help me with my definition? Yes / No

 Do I have others that are better? Yes / No

 Find and keep only the best.

How would I feel about someone finding this item after I pass away?

What (people, things, events) helped turn me into who I am today?

 Does this photo or item help me remember where I came from?
 Yes / No

 Is this a part of my past that I want to remember? Yes / No

Is this still important to me? Yes / No Why: _____

Are there better pictures or memory triggers to help remember this
 event or this specific time in my life? Yes / No

 Comments: _____

If you are looking at memorabilia (like a child's schoolwork or trophy), take a look at chapter 8 for ideas for helping to preserve these.

Sort Pictures and Memorabilia

As you make piles to sort your photos and memorabilia, remember to label and take notes about the piles, pictures, and memories as you go (see chapter 5 for assistance).

How you sort your pictures and memorabilia will depend on you and your final vision. If you haven't thought about this already, and are hoping you could just keep reading, I suggest that you stop and make a plan. It's okay to pause and think about what you really want to do.

- How do I really want to enjoy my memories?
- Why am I taking pictures and saving mementos from moments in my life?

It's fine if you do not care about scrapbooking and just want to keep everything in a box. That's the idea behind the hope chest – for things you want to save to remember for the future. Maybe something you can grab in case of emergency? Maybe just a few special books of memories from special occasions like your wedding, baby, and a special trip? Decorative photo boxes? Online location for digital photo files to grab in case of emergency? You decide!

The most important part is having a plan. You wouldn't try to cook a new meal without a recipe. The same is true for sorting your pictures. Think about why you took the pictures and how you want to enjoy, share, and preserve them.

Physical Items

Making piles is the way to go. Start by making a main pile for each larger project you want to accomplish. For example, if you are sorting chronologically, put each picture into the appropriate year pile.

Then take each larger pile and sort into smaller piles which help

define them better. Again, if you are working chronologically, put each picture into the appropriate month or season pile.

Continue taking each pile and breaking it down into smaller piles until everything is sorted the way you want it.

Chronological Sort

If you want everything chronological:

1. Yearly: sort each picture and piece of memorabilia into the appropriate year.

2. Monthly: sort each of the yearly piles into monthly piles, such as: January, February, March, etc.

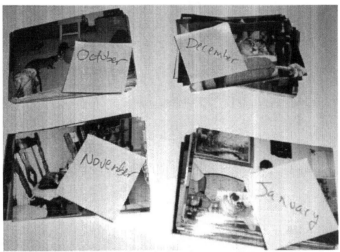

Sorting into monthly piles before breaking down into smaller piles.

3. Seasonally: if it's too difficult to narrow-down to a month, how about by a season? Piles may include: Winter, Spring, Summer and Fall.

4. Date: put the pictures in order, by the date taken. You can use a calendar or a date stamp, on the back or front of the photo, to help with this step.

5. Order of events: sort each day in the order of when things occurred.

 Example: For a birthday, you wouldn't want photos of blowing out the candles after photos of people eating the cake.

You decide how far you want to sort. You can keep everything in the first pile or work down to the specific picture order.

If you cannot figure out which month or season the picture came from, look for clues in the pictures. You may notice a Christmas tree, snow or flowers. Then you can compare outfits and people to get a better idea of time.

You don't need to sort it perfectly, and chronological sorting won't work for every project.

Example:

> *Jill was trying to use her mom's hairstyles as a guide to help determine dates. It was getting very frustrating as there seemed to be a lack of consistency.*
>
> *When she asked her mother, it turned out she sometimes wore wigs! It wasn't the same wig over a certain period of time. She would switch them around – different styles, lengths, etc. on any given day of the week.*
>
> *In this case, trying to sort chronologically may be too difficult and frustrating.*
>
> *You could insert random pictures of Mom where you think they would fit best. Her at a certain place or event? Seasons?*

Just because chronological sorting might not be exact, there are other ways to sort and still enjoy the pictures and memories. You could also put photos in a more loose chronological order, such as by decades: "The 60's", "The 70's, "The 80's".

Event Sort

If you are sorting through a special day, break the day into its special parts. Then sort each of these into the order you want to store them – maybe in chronological order or another way.

Example of your wedding day.

1. Write down the parts of the day which will be included and the order you want it to be stored.

2. Create piles for each part of the event.

 Examples: getting ready, each part of the wedding ceremony, receiving line, wedding party, reception, and guests.

3. Once you have sorted them into the groups you want, you can sort the individual pictures, so they're in the final order you want.

Genealogy Sort

Historical family photos can be the most difficult to sort, journal and enjoy. The older the pictures are, the harder they will be to identify.

It will help if you write yourself notes and/or have a family tree available where you can keep track of family units down to spouses and children.

Start out with two piles – one for each branch of the tree: paternal and maternal. Then move to the branches of each tree – their parents, siblings, etc.

An older relative can help you label people in the pictures and tell you their stories.

Remember to write down as much information as you can about each person and picture. If you have questions about any

of them, make yourself a note to talk with a relative who may have the answers.

Example of going through a mother's box of old pictures:

Nancy had a large box of unlabeled family photos. She was able to gather enough information, by looking at the photos, to sort them into piles. When she was not sure, it would be put in the "Florida" (vacations) pile. We laughed because the Florida pile was so large.

After she finalized the piles, she put each into their own photo album. She had an album for her mother, an album for her father, and another album of them together.

If she wasn't sure about the identity of people in the photos with her mother, since she had no one around to ask, she cropped them out of the picture all together. Sometimes though, she left the photos untouched, hoping to find out later who the other people were.

This made sense to her, and now she can enjoy her pictures. Before this, they were in Rubbermaid totes in the basement.

Not interested in sorting the way that Nancy did? How about sorting according to your family tree? Start at you or back as far as you'd like. Do what makes sense for you.

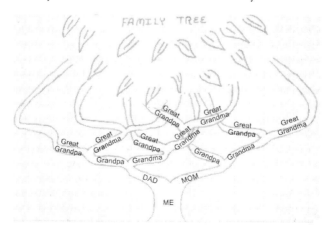

Do not forget the journal, notes, and/or calendar to help keep everything together.

Remember to write about each group of pictures, events or people to store with your pictures. See the next chapter to help you wrote about the photos, so they'll continue to speak even after you are unable to.

Making copies

You may have one picture that you want to put in many different piles. Maybe you've decided to make an album for each of your three children, but you only have one copy of the picture.

Make a pile of pictures to be copied. Write on them (Post-its work great for this) how many and which piles they'll go in when you are done making those copies. With luck, you still have the original negative or digital photo file. Insert a note where you've pulled out the negative, disc, or picture, so you can easily put it back when you've finished making the copies.

Promise yourself to make those copies soon. If you wait too long, you will lose momentum, forget what you had in mind, and add additional piles to sort through.

If it helps, put everything in your car, so you'll remember the next time you are at the store. You can also make a note on your calendar or day planner to be sure you remember to make copies. Copies online are easy, too.[2]

If you aren't using the negatives or digital photo files, is there a reason you should keep them? If all your pictures are printed, I give you permission to toss the negatives or the digital photo files. Do what makes sense for you.

Digital

When it comes to sorting digital photo files, you should have a plan,

[2] See chapter 6, under "Digital" if you're looking for assistance with printing digital files.

just like with physical items. What do you want to be able to do with your digital photo files? Print them? Scrapbook them? Make digital books? Just store them electronically, so you are able to view them again when you want? Have your favorites in a digital photo frame to see all the time?

Please be careful when it comes to digital files. They can become corrupted (so the file cannot be read or viewed again), deleted (by accident or because of hardware failure) and become unreadable as newer computer formats become available. Please print pictures you think are important! It's the only way to assure you will still have the picture available to see again in the future.[2]

> Please print pictures you think are important! It's the only way to assure you will still have the picture available to see again in the future.

Sorting digital photo files is very similar to sorting physical pictures expect all the files are stored electronically. They can be on discs, external hard drives, USB flash drives, personal computers and handheld devices.

We'll still be making piles and sorting, but it will all be on the computer. If you do not have a computer, sort data discs of picture files.

It's about sorting and labeling – labeling being key – especially on the data discs and/or other forms you may be storing digital photo files.

Ways of labeling discs include:

- With a permanent marker on the outside of the disc, being careful not to mark the side the data is stored.

- If you're concerned that writing on a disc may keep it from reading properly, use a permanent marker to write in the middle ring where no data is stored.

- Use the jewel case label to write notes about what's

inside the case. The more specific the information, the easier it will be to find a digital photo images.

- Make a note on a small piece of paper that can be attached to the disc or slipped inside its sleeve.

Labeled on outside of disc

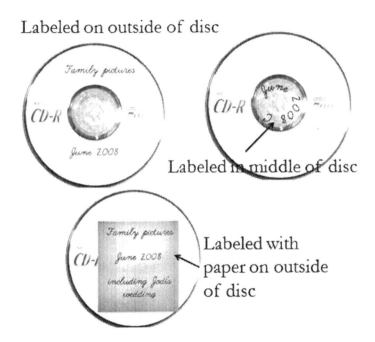

Labeled in middle of disc

Labeled with paper on outside of disc

Depending on your computer savvy, and whether you are a visual person, sorting digital photo images may be easier or harder than sorting physical items. [I find sorting on a computer to be difficult because there are no physical pictures or piles to look at.]

But in some ways this can be easier, especially if you are looking to sort in a chronological order. You can use file names, which are most likely in a number sequence, or the date (and time) the picture was taken to help.

Please keep at least two copies of all files while you are sorting.

Please keep at least two copies of all files while you are sorting. I made the mistake of moving everything to an external hard drive and

tossing the original discs. The hard drive crashed, and I lost it all!

You can choose to use discs created at your local store, a photo organizing software, or your computer's directory structure to help you sort pictures into logical groups.

No Computer, No Problem

With the price of digital cameras coming down and the ease of printing at local stores, you can still own and use a digital camera even if you do not own a computer. In the past, this would have been impossible or extremely difficult to do.

If you do not own a computer, keep copies of your digital photo files on discs. You can purchase discs as well as print your photos from a local store. Keeping discs is similar to keeping negatives from film cameras; they're the easiest way to get reprints of your photos.

When you are ready to print your digital photo images, many stores will allow you to purchase a discs of digital photo images along with the printed pic-

Depending on the store, you may be able to view your pictures on a DVD player in your home in the form of a slide show.

tures. You can also purchase a disc of the digital photo images without the photos. It is important to get a discs, or two, to assure you do not lose any of your digital photo images. Depending on the store (you can ask and shop around), you may be able to view your pictures on a DVD player in your home in the form of a slide show. This is a <u>great</u> feature, and I highly recommend this option.

When you have a disc burnt for you, be sure you label it well so that you know what's on it. This is especially important if you do not have a computer to easily look at the disc later.

When you label your discs, keep a notebook or other paper notes that help you remember what's on each disc along with the stories behind the images. An index print, sometimes costing a little extra, is a great way to visually see what is on each disc.

Once you've had your digital photo images turned into a disc and/or printed, it's okay to remove them from your memory card. You can choose to delete them all or reformat your memory card. Check your camera's manual on how to do this and the best options for your camera.

If you ever want copies of the pictures on the disc, bring the disc back to a local store, and they will gladly print the pictures you want from the disc.

During the printing process, you will have the opportunity to make enhancements to your digital photo images before printing them. Enhancements you may be able to find include: red-eye removal, cropping (zooming in) and even lightening darker images.

Photo Organizing Software

When we got our first digital camera in 2001, there were few software programs available to help manage and enhance digital photo images. I used different software programs to make up-dates to pictures depending on what I wanted. If I wanted to crop the picture, I had to use one software program. If I wanted to shrink the size for emailing, I used another program. If I wanted a great way for sorting my pictures – forget about it. That was not an option.

Now, we have plenty of great choices. Some are easier to use than others. There are both free photo organizing software, and software you can purchase. Some cameras even come with their own software.

Companies are constantly making new photo organizing software to help with our data needs. Software packages keep changing and improving. What might work great for me today might not fit my needs tomorrow. You will want to be sure that your photo organizing software meets your current needs and keeps up with technology.

When looking for software to help you manage your digital photo files, look for something that fits your goals. You will

want the software to work and think similarly to the way you do. If it does not make sense, you will not use it. It will be frustrating, and you will feel like you have wasted time and money.

When you start looking around for what you'd like to use, ask yourself questions about your picture taking habits and the software you're considering. This will help you choose the photo organizing software that will work best for you and your needs.

Think about your photo taking habits and how you'd like to organize your digital photo files.

Think about what you use to take pictures. If most of your digital photo files are on your cell phone and you want to use your computer to sort and store your digital photo images, do you know how to get the files from your cell phone to your computer? Will this be something you can do? Will there be a better solution for you instead of using the computer?

I want you to succeed in keeping your digital photo files in one location, sorted and stored. If there are too many steps involved, you probably won't maintain it. Keep this in mind when you think about how you take pictures and how you want to sort and store them.

Now that you know where your digital photo files are, what file formats do you have? What other types might your cameras use? Examples include JPEG, TIFF, GIF, and PNG. Once you know the types of files you have, make sure the photo organizing software will support them.

Once you have determined how you take pictures and where you want your photo organizing software to reside, research how the software program will run and manipulate your digital photo images

What am I using to take pictures:		
Digital Camera?	Yes / No	Most? Yes / No
Film Camera?	Yes / No	Most? Yes / No
Mobile phone?	Yes / No	Most? Yes / No

Other? Yes / No Most? Yes / No

Where I want to organize my digital photo files:

Online

On computer

Other: _____

Number of steps to move the digital photo files into the
photo organizing software: _____

List steps here: _____

File formats (i.e. JPG, MOV, WAV, PNG) I am using:

File formats offered by the photo organizing software:

How does the photo organizing software handle my photos?

When you first install and run the photo organizing software,
how will it find your pictures? Is the software a grabber or a
pointer?

<u>Grabber?</u>

Some software programs will pull your digital photo files
into itself. I'm calling them a grabber because they'll grab
and hold onto the files. They keep their own copies of all
the digital photo files they are using and thus have full
control of them.

Software programs which are grabbers may tell you that
the amount of disk space needed will vary. As you add
digital photo files, more computer disk space will be used.

<u>Pointer?</u>

Some software doesn't want the responsibility of con-

trolling your digital photo files. Instead, it just points to where your files are located (usually, where you downloaded them from your camera).

If someone accidentally moves or deletes the digital photo files from your computer, the photo organizing software will be unable to find your digital photo files. They'll be as good as lost. The software isn't smart enough to know where you moved the files to. It just knows where they were last.

I recommend and prefer the software programs that I referred to as "grabbers." They take up more disk space because they pull in all your digital photo files, but are safer for keeping your digital photo files where you can always find them.

❧❧ ❧❧ ❧❧ ❧❧ ❧❧ ❧❧ ❧❧ ❧❧

Now that we know where the photo organizing software has your picture files, let's talk about other things the software can do. Do you want to be able to put digital photo file in multiple groups or piles? How many will it allow? How many will you need?

When it comes to putting one digital photo file in multiple piles, how does the software put items into piles? Is it like the grabber or the pointer?

If the photo organizing software is like the grabber, it will pull a new file into each group you create. Think of it like making multiple copies to put into separate filing cabinet folders. Each folder has its own separate digital photo file. If you make changes to one digital photo file, it won't affect the other digital photo file. This might be good, but this might be bad. What if you're making enhancements? Do you want to make the same changes for each group's files?

If the photo organizing software is a pointer, it has one location where the original digital photo file is. When changes are made, it affects the original file. Again, this could be good or bad depending on what you are doing to the original digital

photo file.

For this reason, it's good to know if your software will keep your original file and save copies of each updated digital photo file. Can this feature be turned on or off?

Photo organizing software is a:

- Grabber

- Pointer

My preference: _____

Number of groups or albums offered by photo organizing software: _____

When digital photo files are in multiple groups, the software is:

- Grabber

- Pointer

My preference: _____

Other notes: _____

When working with the original digital photo file, the digital organizing software:

- Protects original digital photo file

- Overwrites original digital photo file

- Offers the option to overwrite original digital photo file

Does the photo organizing software offer enhancement options to make your digital photo files better?

Does the photo organizing software offer photo image enhancements? Does it have options for journaling? Even if you can't add notes in your software, remember to write about your pictures so you won't lose the special meanings behind them.

What types of enhancements do you want?

Are there other features you'd like your photo organizing software to offer? Other things you might want to consider include:

- Will the software link to social media sites I use?
- Does the software offer email options to help email pictures to friends and family?

As you may have noticed, digital photo file can be large in size. The size of the photos might be considered too large to email to others. In this case, it's nice to have a photo organizing software that will convert them to a smaller size. These smaller sized files can then be emailed to friends and family. Sometimes software will even place the smaller file into a message for you.

The photo organizing software offers journaling options: Yes / No

Comments: _____

Digital enhancements available through the photo organizing software:

- Cropping
- Cloning (remove unwanted pieces of pictures)
- Red-eye removal
- Resizing
- Lightening dark pictures
- Make sepia print from color digital photo image
- Make black and white print from color digital photo image

Other enhancements: _____

The photo organizing software links to social media sites:

The software offers email options: _____

Consider how easy the photo organizing software is to use.

Now that you should have narrowed down your choices of photo organizing software, ask it a few more questions about how it will work for you.

Where I want to run the photo organizing software:

Computer

Mobile device

Online

Other: _____

Computer requirements for the photo organizing software:

Computer operating system required: _____

Disk space required: _____

Additional software installed: _____

Can I try the software before purchasing it? Yes / No

Is the software easy for me to use? Yes / No

Do I know others using this software? Yes / No

Who? _____

Comments about the software: _____

Other reviews about this software: _____

Backup your digital photo files!

The most important part of any good storage solution is being able to backup the digital photo files. If the process of backing up is seamless, it will be done regularly so your photos aren't lost.

If software doesn't reside on your computer, will you be able to backup your files?

Backup options available in the software:

Reminder feature

Automatic backups

Other: _____

How I plan to backup my digital photo files

Schedule a time to backup my digital photo files:

If the photo organizing software runs online: can I make a copy on my computer? Yes / No

Notes: _____

Remember to remove those blurry, accidental and duplicated pictures (as discussed earlier). When you go back to the photo organizing software, you will be able to quickly and easily find just what you are looking for. Go back to "Purge Bad Pictures and Memories" section, if needed.

Remember to backup your files!

As you continue to add pictures and stories, remember to backup your files.

The Cheapest Storage and Sorting Option

If you are comfortable with your computer, you do not require fancy software to store and sort your digital photo files. If you do not feel very comfortable using your computer, I would recommend taking a class or finding a software program that can help you.

To store your pictures on your computer using directories, you will want to think about how you want your pictures sorted. Because digital files are named in chronological order, by month and year will be the easiest for you. I encourage you to store

digital photo files in the way it makes most sense to you, so you know where to find the digital photo images later.

Decide where you want to store your picture files. I recommend in "My Pictures" or "Pictures" (depending on your computer's operating system) directory. You will then have everything in one place for backup and recovery purposes. It will also make for an easier transition when you get a new computer.

In the "My Pictures" directory, create a sub-directory for pictures (do not use "Pictures" or "My Pictures", though you can use this pre-designed directory). If you use "My Pictures," create another directory, so you know where you placed your pictures. If you put everything in the main directory, it will get clogged up with other picture files that may not be related to your family.

Consider a sub-directory of "Family Pictures" or "My Family." Then you will create a new directory for each pile you wish to make for your pictures.

For example, create an "April 2011" folder and put all the pictures taken in April 2011 in this folder. If you are like me and enjoy being able to see the directories in order, label them with numbers first.

Choose the naming scheme that works for you.

- Start with a 2-digit year with a 2-digit month. For April 2012, you could create a folder: **1204 April**

- Start with a 4-digit year with a 2-digit month. For April 2012, you could create a folder: **201204 April**

- Start with a 2- or 4-digit year with a 2-digit month, separated by a dash. For April 2012, you can create a folder: **12-04 April** or **2012-04 April**

- In order to keep the latest month or year at the top of your list of directories, add an underscore or asterisk to the beginning of the name.

For example: change **1204 April** to **_1204 April**

If you want to sort your pictures further into other special occasions that happened in a specific month, create a sub-folder with its name. If it's a wedding, you can create a "wedding" folder, or "1204_wedding."

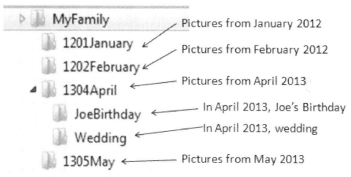

Example of chronological directory structure

Another way to organize folders is by name.

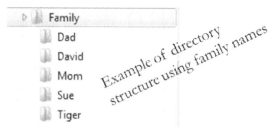

If you want them to appear in a specific order, you can add numbers or symbols in front of the folders to sort them the way you prefer. You can create any names you want.

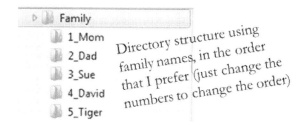

The best part about this method is you can easily create new folders for anything you need. You do not have to worry about updating your photo organizing software as you change operating systems.

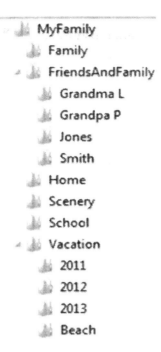

MyFamily
Family
FriendsAndFamily
Grandma L
Grandpa P
Jones
Smith
Home
Scenery
School
Vacation
2011
2012
2013
Beach

Remember when I talked about collecting pictures and suggested grabbing a notebook to write about the pictures and memorabilia you have? I still want you to do that. You can grab a notebook, create a text file or other file (perhaps using WordPad or Microsoft Word) with information about the pictures you have stored in each directory.

You will be glad you kept this information when you go back to enjoy the pictures in each folder.

Another thing to keep in mind is removing those blurry, accidental and duplicate pictures (as discussed earlier). When you go back to a directory, you will be able to quickly and easily find just what you are looking for to enjoy those memories and stories. Go back to the "Purge Bad Pictures and Memories" section, if needed.

For enhancements, you can use special software or update your digital photo images where you get your pictures printed. Most stores and online services offer enhancements like: cropping, red-eye removal and lightening darker images.

Last step – backup your digital photo files! Always keep at least two copies of all files!

Always keep at least two copies of all files!

Final Notes

Now that you know how to sort, set up time for yourself to work.

Remember, you do not have to do it alone. Get together with friends, join a crop club (for scrapbookers; but you do not have to scrapbook to join one), or make it a family event. It may be a lot of fun sorting and writing notes with others to remember all the pieces of events that you may have forgotten.

Friends and family are also great resources for helping determine which pictures to keep and which to purge.

While you are working, do not forget the journal, notes, and/or calendar to help keep everything together and help it make a lot more sense.

5: WRITE

Before George Eastman put a camera in everyone's hands, stories were told, retold and passed down from generation to generation. In this fast-paced world, a lot of that has been lost.

Why? We enjoy other forms of entertainment and think that by taking pictures, we are preserving these parts of our history.

Unfortunately, as we take more pictures, we tend to tell less of the stories behind the pictures. We forget to save the stories of our lives. We think that "a picture is worth a thousand words," so we don't worry about telling our stories.

Remember the picture of my grandmother from the 1940s? It's a perfect example of stories being lost because no one is writing it down.

So, while you are collecting, sorting, and storing your photos and memorabilia, please remember to write. Write about all the important pieces of the history of your life! Use your pictures and/or calendar as a guide for what to write about.

Start to journal as you sort your pictures. You can write notes on paper or talk into a recorder. As you find different pictures and other memorabilia, they'll probably bring back memories. Write about the memories when they are still fresh in your mind. Tell the who, what, where, when, and why. Also write about the other feelings and memories that come up like the smell of the ocean, the overall fun of the trip, the special meaning of that specific location or item. Remember the traditions and any history behind the tradition.

Example:

When I was younger, we used to spend every Fourth of July at my grandparent's cottage on one of the Finger Lakes. I have fond memories of the camp fire, sparklers, and the lake alight with fireworks.

Now that I have a family of my own, I had the opportunity to share this memory with my children. I love that they now share the same fun of the campfire, sparklers, and fireworks. When looking back at these pictures, I will include my past memories along with the new ones. This makes the holiday even more special because of the history behind it.

In 1978, we baptized my baby brother, Karl, at the cottage.

In 2011, baptism includes a ride on "Big Bertha," the large inner tube.

I've done a similar exercise with boxes of old toys and books I've put away for my kids for when they're older. This may be part of the memories you are keeping and can be a later step for you to go

through, too. I've been making notes about how a specific book was a favorite, how a certain stuffed animal was their first gift at the hospital when they were born, etc. By doing this now, when the boxes are opened again, I will remember *why* the items were kept. If this is after my death, my children will know which items are theirs, why they were kept, and why I thought they were special.

Just because the item is no longer available does not mean you cannot write about it. Maybe it was lost years ago. You can still write about it. In fact, that's a great way to keep its memory alive.

Example:

Diane had had many floods in homes throughout the years. In the process, she'd lost many special memories. The ones that were most upsetting were two autographs from her favorite musical artist, Harry Belafonte.

By sharing this story with others and writing it down, it still will be remembered for the special memory it is.

At a young age of about six or seven, she saw Mr. Belafonte in concert. She went back stage to meet him. Unfortunately, it was very busy back there and a security guard yelled at the crowd that whoever did not belong back there should leave. At this young age, she obeyed but was rather upset missing out on meeting her idol.

Diane's father tried to comfort her by telling her that the security guard was not yelling at her. She later wrote to Mr. Belafonte to tell about this experience, and he sent her an autographed picture.

The next time he was in town, she and her family saw him in concert. He made sure to get her and her sisters each an autographed program and invited them back stage after the concert. She has a special picture of this encounter, but a flood ruined the autograph and thoughtful note he wrote to her.

You do not have to write in any specific location. You also do not have to spend a lot of time. When you have a baby, there are lots of gifts which include ways to document the baby's first milestones and that first year of life. If you are a parent, you know the time is limited when you have a newborn.

Use the same steps you would with a baby to keep track of the important parts of your life and your family. You can use a journal (paper or on a computer), calendar, back of pictures, index cards stored with images and/or memorabilia. Please note that index cards will probably be unsafe to store, touching your pictures. Please put something buffered between them and your pictures.

Remember to think about favorite things you like to do, favorite songs, feelings and related memories which make the current memory even more special.

You can write on the backs of photos as long as you write with something made specifically for this.

You can also use photo safe paper to write on and store between pictures. See chapter 6 to learn more about what is safe for storing your photos.

As you find negatives, remember to label them, too.

You can also store calendars and journals with your pictures and memorabilia.

<div align="center">

✌✗ ✌✗ ✌✗ ✌✗ ✌✗ ✌✗ ✌✗ ✌✗

</div>

So, how do you know if you've written enough to help you and others remember the memories of a particular photo? Try the friend test. Most of us get very excited to share our photographs with our friends. We find ourselves hovering over them as they flip through our pictures. We don't want to miss any special detail.

If you've written enough, you should be able to hand your journal and photographs to a friend and walk away. If you didn't miss something you'd say in person, then you wrote about everything you would have said. Try reading your words out loud to assure you didn't miss anything.

6: STORE

"A place for everything and everything in its place."
Isabella Mary Beeton

I believe that storage is the most important chapter.

If you are unable to do anything else, <u>please</u> store your memories properly, so you can enjoy them for years to come.

By now, I'm sure you know <u>how</u> you want to store your memories, so this section is organized by solutions and what to look for to keep your memories safe.

When it comes to saving your precious memories, you will find that some things should be kept far away from your valuable pictures!

Things to watch out for:

Acid

You will see many supplies labeled as "Acid-Free." As I write this, there are no actual rules to what acid-free means, so please be careful of what you purchase. Just because it says it is acid-free does not always mean it's really acid-free.

True acid-free paper will have a neutral pH or pH of 7

or higher. Buffered paper will help keep things that are acid-ic from ruining other items which are close by. Acid is locked into the paper instead of being allowed to roam to other items, which it likes to do. Think of it as spreading like an ink spot unless controlled.

Greeting cards are a popular item to hold onto. If they come in contact with your pictures, they can ruin the images over time, as most regular paper contains acid.

Acid can pull colors out of your images or even wash them out. I've seen Polaroid images turn green. I've also seen splotches of bright color show up on images in strange places from the acid exposure.

There is a lot of acid in construction paper. Have you noticed how quickly it fades? That's why.

Bottom line, acid is BAD!

Bottom line, acid is bad!

Polyvinyl chloride (PVC)

PVC can fade your photos and even transfer the image to other media when in contact with your images. It's best to stay away from anything with PVC in it. Many boxes and albums will now say they are PVC-free.

Regular cardboard and paper

Cardboard and paper retains water and can easily stick to your photos if there is extra moisture in your environment caused by anything from summer humidity, normal base-ment humidity, to floods.

Even the paper envelopes that your photos come in, when processed, are not safe for your photos. They are only meant as temporary storage. I've heard them get stuck to photos in water damage situations and many times the pictures are not recoverable.

Lignin

Lignin causes your pages to turn yellow and can ruin your pictures like acid does.

Lignin is something which is part of wood, so it's found in paper. It can only be removed chemically, so unless it says "lignin-free," there's lignin in your paper.

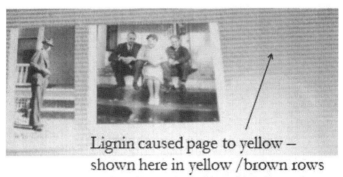

Lignin caused page to yellow –
shown here in yellow / brown rows

Example of the yellowing page from a self-stick photo album. Luckily, these old images have not been thoroughly damaged by the lignin or acid.

There's a lot of lignin in newspapers. That's why it turns yellow so quickly. Please keep newspapers far away from your photos.

Light

Over time, light will ruin and fade your images. Sunlight is the worse!

Try to keep your images in a dark place as much as possible to preserve them. Dark storage boxes and photo albums are best.

Extreme heat, cold, and moisture

Keep your photos and other items in a climate similar to the one you enjoy. Since heat and humidity can damage your

photos and negatives, store them in your main living areas and not in extreme temperature zones like your basement or attic.

Keep in mind that extreme heat and moisture comes from the kitchen and bathroom, so keep photos away from those rooms. You may also consider keeping them out of closets that have pipes that might leak.

> **Keep your photos and other items in a climate similar to the one you enjoy.**

Example:

I received a desperate call one spring day from my friend Patty. She told me how her friend, Cara, had water-logged photos. The basement had flooded and the box of photos was submerged.

Luckily, Patty didn't need to do anything fancy to dry the photos out. There are websites available online if you need more assistance than Patty did. Each situation is different, and there are many experts available at your fingertips.

Patty and Cara were able to pull most of the photos apart. A few pictures were ruined when they were unable to be removed from the envelope they were stored.

After everything was pulled apart, Patty laid the photos out in the sun. Some photos began to melt. A few were placed too close to each other and began to stick together.

The moral of the story: don't store your photos in paper envelopes or basements. You won't have to lay wet pictures out on your lawn.

<center>❧❧ ❧❧ ❧❧ ❧❧ ❧❧ ❧❧ ❧❧ ❧❧</center>

If you are not sure how safe an item is, you can see if it's passed the Photographic Activity Test (PAT). If products pass this test, they are safe to use with your photos. (See the glossary for what PAT is)

As for this chapter, feel free to read the entire thing or just the

sections that apply to you. Here is how the sections are sorted if you'd like to skip around:

Photo Boxes

Photo Boxes are great for pictures, negatives, picture discs, and smaller/flat memorabilia.

When you are considering a Photo Box, please pay attention to the things I mention at the beginning of this chapter as being bad for your images. Boxes which are not made from paper or cardboard would be your better choices. Stay away from see-through boxes, too. Light will get to your images and over time, fade them.

Reminder – keep away from:

- Acid
- Polyvinyl chloride (PVC)
- Regular cardboard and paper
- Lignin
- Light
- Extreme heat, cold, and moisture

When looking for a storage container, you may want to consider the size of the box. If most of your photographs are 8x10, a 4x6 box will be unable to hold most of your images. Depending on the

number of pictures you have and will be adding over time, you may want to consider one that offers pockets or walls to help corral photos in a smaller space. When you begin filling a box, the pictures will slide all over until it's full enough to keep them tightly packed.

Since your photos will probably be in storage for some time before you are able to put them in albums, frames, or another ideal location, I suggest getting the best and safest photo box for your photos. This is one area where you do not want to skimp.

Frames

Frames are one of the most popular ways of displaying pictures around your home.

Traditional Frames

When using a regular frame, there are a few things to keep in mind. Never put original pictures into a frame. This is especially true of older pictures which have no replacements/duplicates. Light can ruin photos, as well as the glass that is in direct contact with your image.

When matting your photographs, it's best to use photo safe products which are acid-free. Photo mats and the backboard touch your photo and can cause damage if it isn't good quality. Remember to mat your photos because you do not want your picture

> Be sure to use a photo mat to prevent photographs from sticking to the glass of the frame. Never put original pictures into a frame.

touching the glass. Matting your pictures is not just for looks. Moisture can easily get into the frame, causing the picture to stick to the glass. Even just an extra warm summer day may cause this.

Displaying images without a traditional frame is even more dangerous for images, so please use duplicate images for these types of displays.

Digital Frames

If you love displaying pictures, the digital frame is a great choice for your digital photo images.

When looking for a digital frame, it can be confusing. Ask some questions, so you can get the best deal for your money.

Where are most of your digital photo files? On your computer? Cell phone? Other device? Digital frames have different ways of loading your digital photo images. Before purchasing one, verify where your digital photo files are and where they need to be moved in order to use the frame.

Think about the number of steps needed to move files from your "camera" (or wherever your digital photo files are currently located) to your frame. If there are too many steps, it may not be easy to use.

Digital frames have different options for storing your digital photo images. Some require digital photo images to be downloaded from a memory card. Others function with an inserted memory card of digital photo files. Change photos by changing memory cards. Some frames will connect to your computer to upload pictures from your computer to the frame.

Questions when considering a digital frame:

What am I using to take pictures:

Digital Camera?	Yes / No	Most? Yes / No
Film Camera?	Yes / No	Most? Yes / No
Mobile phone?	Yes / No	Most? Yes / No
Other?	Yes / No	Most? Yes / No

Types of images I want to display in my digital photo frame: _____

Where these digital photo files are located now:
Online

On computer

Mobile device

Physical pictures

Other: _____

Number of steps to move the digital photo files into the digital frame? _____

List steps here: _____

Load frame with:

Memory card

- Kept in frame

- Used to download digital photo files to frame

PC or Mac?

I would prefer: _____ because _____.

Additional questions I'd like to ask:

Technology continues to improve and change. Many new and exciting products will continue to become available over time.

Photo Albums

Traditional Photo Albums

Traditional photo albums are albums which you put already printed pictures and memorabilia. They can be scrapbooks or other types of albums.

When it comes to albums, please be sure to get the best product to keep your special memories safe! Refer to the list at the front of this chapter for things to avoid!

Reminder – keep away from:

🖊 Acid

- ❖ Polyvinyl chloride (PVC)
- ❖ Regular cardboard and paper
- ❖ Lignin
- ❖ Light
- ❖ Extreme heat, cold, and moisture

Photo albums don't have to be fancy. You can keep your pictures in a slide-in album which allows easy access to your photos and stories. You can get fancy and do a scrapbook. Album storage makes it much easier to view your images than box storage.

Most of us do not have time to move newly printed pictures right into an album or put all of our printed images into an album. I suggest using a photo box as a temporary home before you are able to place the pictures into an album. Photo boxes also work great for holding extra images, negatives as well as picture discs. (See the "Photo Boxes" section earlier in this chapter)

Purchase the best quality products for the best photo preservation! Here are things you should look for in an album (in addition to the "keep away" list).

- ❖ Avoid acid:

 Acid-free is a great idea, though you cannot always be sure what you are getting as there are no set rules in the industry. Buffered paper is a great choice!

 If you put items with acid with your photos, it may migrate into your photos and ruin them. This can include stickers, post cards and greeting cards.

- ❖ Avoid self-stick albums, many times referred to as "magnetic albums":

 These albums have adhesive which is really bad for your photos. The acid and other chemicals can destroy the

coloring of your photos. I've experienced colored splotches, all blue Polaroid photos, and faded photos.

The pages are also full of lignin and yellow very quickly.

Then there's the issue of trying to remove the photos. Sometimes they fall right off because the adhesive is not sticky enough to endure over time. Other times, pictures cannot be removed without ripping them.

💣 Avoid unprotected pages:

Make sure your album has a plastic coating (PVC-free) to cover your photos and stories. Dust, liquids, and finger prints can ruin unprotected photos.

If you are using a scrapbook with page protectors (slipped over the page in order to protect what's on the page), I highly recommend ones that slip over the page so that the top of the page is protected.

Why? Have you ever left a book on a shelf for a while, or in an old home with a lot of dust? Dust settles on the tops of the pages of books. If the pages are not protected at the top, where do you think the dust will go? Of course, it will go down into the pocket where your pictures were so carefully placed.

💣 Avoid pages which do not lay flat:

If you are using an album which has pages that do not lay flat when opened, over time items on the creases will begin to bend and break. This may take time, but why take chances with your priceless memories?

💣 Avoid storing albums on their sides:

Books are meant to be placed on bookshelves so the spines are out and upright on the shelf. The spines are

meant to help hold the weight of the overall book. If you store your photo albums on their sides, they may begin to warp. As the album settles, things may stick-together. Anything you put on the pages which is not flat will begin to add its indentation on the pages around it.

Example: I almost ruined my engagement picture due to a 3-D sticker that I placed on the opposite page. Luckily, I replaced it within a few years. Although there's still a small dent, it could have been much worse.

🔥 Avoid overstuffing albums:

Many albums allow you to add, remove, and rearrange pages. In these types of albums, it's easy to add too many pages or even create thick pages with lots of papers and other embellishments. When adding pages to your album, make sure that you do not overstuff your book! You want it to be able to lay flat and not bulge out if lying on its side.

If you overstuff your album, it may begin to split the binding where most of the weight is distributed.

🔥 Avoid unsafe adhesives on scrapbooks:

Adhesive is the glue which adheres your picture or other memorabilia onto your scrapbook page. Not all adhesives are created equal.

Not all adhesives are created equal.

Make sure your adhesive is made specifically for photos. You wouldn't want it to warp your picture. Have you ever used white glue on paper and noticed how it gets wavy from the moisture of the glue? You do not want this to happen to pictures that you cherish.

Adhesive should not crack or loosen your pictures from the page. Have you ever used tape on a book to repair it? Maybe you have one that was repaired by

someone else. The tape will eventually become brittle, turn yellow and fall off of the book. This can occur with your adhesive if you do not choose the right one. I don't know about you, but whenever I complete an album, I do not want to have to redo it. I also expect my albums to keep my photos safe.

Digital Photo Albums

Digital photo albums are books created using digital photo images. When completed, it is a physical book to flip through and enjoy.

Making a digital photo album can save you a number of steps and expenses. It eliminates the need to purchase a photo album and print pictures. If you scrapbook, you will also save on purchases of papers, stickers, adhesives, and page protectors.

Creating a digital photo album is a great option if you'd like to make the album once but give it to multiple people. An example of this would be: making a family album for each of your children, or sharing a trip with friends.

Depending on the company you use to create your digital album, you might be able to go back later and print extra copies. This is a great resource if something were to happen to the original book. It is something you cannot do with a traditional photo album.

❧❧ ❧❧ ❧❧ ❧❧ ❧❧ ❧❧ ❧❧ ❧❧

So, you love the idea of creating a digital photo album, but don't know where to start? There are so many options! You can go to a store and have them create one for you. Many kiosks and stores offer this service. You can also go online. There are different ways of creating your book and each company has a different end product. Some bindings are stitched, some are glued. Some pages are thicker and even stain resistant.

If you are in an extreme hurry to get your book completed, you won't like what I have to say: shop around! You want to

find the right company, software, and product that will suitably enhance your enjoyment of your pictures and memories.

Think about what you use to take pictures. If most of your digital photo files are on your cell phone and you want to use your computer to create a digital photo album, do you know how to get the files from your cell phone to your computer? Will this be something you can do? Is there a better solution instead of using the computer?

Besides installing software on your computer, you can create an album using an online company. There are also companies that will do the work for you.

If you use an online company, be aware that you have no control of updates to the software or changes to what you've already completed.

Example:

Laura told me how she started her first digital album online. She was thrilled with how it was coming along. The book was about 90% complete when she went back to finish it. She learned that the software had changed, and she was no longer able to access the album.

She had to start all over. Luckily, she had saved the digital photo files where she could easily retrieve them. Unfortunately, she had to recreate the pages and rewrite the stories.

In case this happens to you, save your stories and pictures together in one location. Consider a new group or directory for each project.

If you have a company create the album for you, what type of input will you get? Can you choose the order of your pictures? Can you add notes or stories to the book?

What am I using to take pictures:		
Digital Camera?	Yes / No	Most? Yes / No
Film Camera?	Yes / No	Most? Yes / No

Mobile phone? Yes / No Most? Yes / No

Other? Yes / No Most? Yes / No

Types of images I want to add in my digital photo album:

Current location of these digital photo files:

Online

On computer

In digital photo organizing software

Other: _____

Location creating digital photo album:

Store: _____

Hire: _____

Online

On computer

Other: _____

Number of steps to move the digital photo files into the digital photo album: _____

List steps here: _____

File formats (i.e. JPG, MOV, WAV, PNG) I am using:

File formats offered by the digital photo album software:

If digital photo album software is installed on my computer:

Disk space required: _____

Compatible with my computer and operating system? Yes / No

Other computer requirements: _____

Software customer support number: _____

As with anything digital, can you backup your album? How? Where?

Think about how the software works and what you want it to do. If you would like to add items which aren't currently digital files, does the company offer to turn physical items into digital files and/or books? Will you need to scan in your own items?

Is there space to add writing to the book? Can you change the size of these spaces? Will you be able to write large and small stories depending on your pictures? Will you be able to change the height of the words? Some companies only offer one sized font. Will you be able to read the words in the photo book?

Is the book easy to create? Do you need to purchase software? Is the software free to use?

Backup options available in the software:

 Reminder feature

 Automatic backups

 Other: _____

How I plan to backup my digital photo album

Schedule a time to backup my digital photo album: _____

If the software to create the photo album runs online: can I make a copy on my computer? Yes / No

Adding non-digital photo files to book:

 Scan in myself

 Scan and get disc at local store

 Send item to company to add to book

 Other: _____

Journaling options:

 Spacing set by company and I am unable to change it

 Options to change journaling on pages

 Other: _____

Ease of use of digital photo album software:

 Preset pages

 Able to change size of pictures on pages? Yes / No

 Able to move pages around as I work? Yes / No

Cost of software: _____

How will the final book be made?

Size of books available:

 Maximum number of pages available: _____

 Maximum number of pictures per page: _____

What will the final book look like?

 Hard cover

 Paperback

 My pictures added to cover

 Stitched binding

 Glued binding

 Other: _____

Once I've completed creating the book,

 How long will the completed book be available to purchase? _____

 How long before the book is delivered? _____

 How many copies can be made? _____

 Cost per book? _____

 Discount for multiple books? _____

 Shipping and Handling fees? _____

 Discount for multiple books? _____

Digital Photo Files

Print Digital Photo Files

A physical print is best for true memory preservation. Remember that hardware fails, software changes, and files get corrupted.

Not all printing is created equal.

Not all printing is created equal.

Because there are so many options, printing your pictures can be very overwhelming.

You can print at a store, online, or at home. At stores, they have chemical processing (similar to that used for 35mm film), dry lab processing and pigment ink printers.

With film cameras, you simply take your roll to the store, and they process it and give you back pictures and negatives. Now if only it had stayed that simple. Those pictures have a life expectancy of about 100 years if treated properly.

If you can get your digital photo images printed with chemicals, as they are with film cameras, you will get the best quality. This produces a picture that will last the test of time (as long as you keep them in the proper location).

Another key word to look for (and ask for) is "pigment-based processing". When I first began looking into processing, many of the do-it-yourself kiosks used dye-based ink causing their pictures to fade quickly. Think about how your favorite T-shirt, also having been printed with dyes, fades in the sun. Now pigment based inks are being used more regularly. It may not be labeled on the machines, so be sure to ask! They should be able to tell you.

The trick is to find a company you like and stick with them. I accidently had the same photo printed at two different locations and quickly discovered that where you go matters as much as what type of camera you use.

If you want to print at home, as more and more of us are doing, I'm sure you'd still like your pictures to last. Here are some things to keep in mind when purchasing a printer specifically for printing photos. I've heard that the best choice for a printer is to get one that uses dye-sublimation. There are a number of advantages and disadvantages to this type of printer. Another option would be to ensure your printer uses pigment-based ink. The paper you use can also make a difference!

After all this, are you wondering if your pictures are safe? Here's a test you can do.

Print your picture and tape it up to the window in your home with the most light (you might want to have part of the picture covered with paper so you can see the difference even easier).

Print two or three of the same picture. Print one picture from your home printer, one picture from a professional location and another either from the store or home. The first two pictures go into the window and are left for about a week or more. The third picture is left in a dark area; this will be your unaffected controlled group.

After a week or two, pull down the pictures from the window and compare them. If the picture is badly faded, this is what will happen to it over time.

Still well
preserved
(tape actually saved it)

Faded

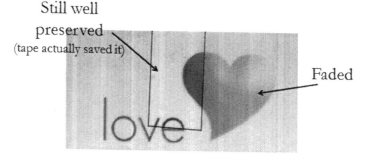

If you enjoy having pictures on your refrigerator, you may have already noticed that they've begun to fade. Try another printing method if you want your pictures to last.

Backup Digital Photo Files

In an ideal world, we'd have all the pictures sorted and saved in a safe place. However, don't let that prevent you backing up all of your digital photo files. They're too important to lose, and "tomorrow" may be the day your computer or memory card crashes.

It's best to have multiple backups! Discs, camera memory cards, and USB flash drives crash, too. Just because all of your photos are on discs, does not mean you will be able to access them again when you want to.

Ideally, you would want to print all your best pictures. Do the best you can. Right now, having multiple backups should be enough. Here's some information to help you understand why:

- Your digital camera's memory card will eventually fail. Be sure to use them only for short-term storage.

- Your computer's hard drive will fail. Many people transfer digital photo files from their memory card and store them on their computer, which is an even riskier move. Hard drives are constantly moving and storing data. They are susceptible to crashes and failure. Many manufactures will publish an expected life expectancy for their products. Yes, your device may last longer, but there's no way to know for sure.

- Not all discs are created equal. Digital photo images don't have negatives as a backup, so saving digital photo files to a CD-R or DVD-R is great solution. Beware: there are many cheaply manufactured discs out there. The quality of the materials used in the manufacturing process is critical to readability and longevity. Cutting costs here can greatly reduce life expectancy.

> Note that CD-RW and DVD-RW discs should never be used for long-term storage.

Also note that CD-RW and DVD-RW discs should never be used for long-term storage. There are other ways to store digital photo files including USB flash drives and external hard drives.

Think about the RW (re-writeable) disc like a sheet of paper which you use a pencil on. You erase it and can write again. After a while, it will be difficult to read and pencil does not last as long as pen.

In contrast, the R (write once) discs are like using a pen, so they're not going to disappear as easily.

- Digital media will change. Remember the floppy disk? Even if the CD/DVD format lasts for years, today's file formats might not. Within 10 years, the industry may come up with something better than JPEG (the compression format most digital cameras use now).

If you are unable to print every single digital photo image you'd like preserved, then you should at least be sure to keep multiple copies. Prepare to adjust to changing technology and hardware failures.

As technology continues to change and improve, options will continue to get better. Save the digital photo files on multiple locations which can include CD-Rs and DVD-Rs (not CD-RWs), USB flash drives, external hard drives, extra internal hard drives, online photo services, and online data services. The more copies, the better!

You can store digital photo files on CDs and DVDs. Keep them in CD jewel cases or CD pockets often known as CD wallets. They are similar to the sleeves used for baseball cards but the correct size for CDs. I love being able to keep all my discs inside one easy-to-carry case. There are many options. Be sure to find something which will zip or close securely to keep extra dust and light away from the CDs. Also, remember to store them where you live. Extreme heat and cold can harm

discs as well as prints. Scratches on either side of the disc can also cause the disc to become unreadable.

You can also store digital photo files on larger storage devices like USB flash drives. They're so small, that you'll want to be sure that they are carefully labeled to know what is on each one.

You can save all of your files including digital photo files to online backup companies.

Having an external hard drive (as a second copy) is a great choice. After you download the pictures from your camera to your computer, backup files to your external hard drive. When you are done, store the hard drive in a fireproof safe or offsite. You can keep it at a friend's home or at work. Because the hard drive is not always hooked up and running, it will last longer than your computer's hard drive. Remember, pictures on the external hard drive will be safer in the fireproof safe or in another location.

If you do not know how to burn a CD or copy files to a USB flash drive or online service, find someone who can help you. You could offer to pay your favorite teenager for a couple of lessons. Many times you can find great classes in the evenings at local high schools that teach computer basics. They'll help you feel more comfortable with your computer and answer all of your questions. It helps if you go into the class knowing what you want to get out of it, so you can ask the questions you need.

Online Services

There are many benefits to using an online service to save your digital photo files. There's no fear from light, heat, acid, or other concerns such as a hard drive crash when your files are backed up online. This makes it possible to access your digital photo files from any computer or from any location.

You can save digital photo files to online backup companies such as Drop Box, Carbonite and Mozy. There are many companies available. When looking for an online company, will they

backup my digital photo files automatically? Some companies will offer automatic backups, and some will require you to do the backing up yourself. Look around for what will work best for you.

Here are some questions to ask when looking for an online backup company.

How long has the company been in business? _____

Backup options available:

 Reminder feature

 Automatic backups

 Other: _____

How I plan to backup my digital photo files

Schedule a time to backup my digital photo files: _____

Company contact number: _____

Company website: _____

Even if you use an online service for backups, please keep at least one extra copy of each file at home, too! Companies go out of business all the time, and other issues may arise which keep you from being able to access your files.

Keep at least one extra backup at home to assure your images are not lost.

There are also online services specifically set up to help you store and print your digital photo images online. Many are free as long as you print photos within a certain amount of time. When looking for a company, look at:

How long do digital photo files remain online? _____

Cost of membership: _____

 Service Fee: _____

 Commitment to purchase prints: _____

 How often: _____

 Other: _____

Disk space available per person or email address: _____

Keep an eye on your account to assure the company does not go out of business without you realizing it.

Again, keep at least one extra backup at home to assure your digital photo images are not lost.

Share Digital Photo Images

With the addition of computers and digital cameras, there are so many more ways to share our pictures and their stories than ever before. In the past, we would send a physical print to friends and family, but now we can do so much more on the computer. We can also display our photographs in a plethora of ways.

Social media and email are becoming very popular ways to share our pictures with those we know. We save money when we don't print our digital photo images or pay for postage. It's a great way to stay in touch with friends and family all over the world.

We can share digital photo images and stories with everyone via email, social media sites such as Facebook, and through online printing sites. We can share with more people in less time than it takes to print and mail our images. If Grandma and Grandpa want a picture of little Suzie for their home, they're able to order their own prints.

With all this quick and easy sharing, it's likely you'll want to share everything! I would like you to think back to my "less is

more" comments from earlier. Try to keep what you share limited. If you took 150 pictures during your trip to Disney, share just a few of your favorites so friends and family can experience some of the fun without feeling overwhelmed by the quantity.

When sharing digital photo images on the Internet, remember to remove older files regularly as you add new ones. Some services limit the amount of space you can use. Even if there is no space limit, you shouldn't keep all of your older pictures out in cyber-space indefinitely.

You may want to create a rule for yourself. Every time you add new photos, remove your oldest album. Or you could do it monthly, weekly, or after printing items from a print website.

7: MAINTAIN

"For changes to be of any true value, they've got to be lasting and consistent."
~ Anthony Robbins (American advisor to leaders)

You've done a great job getting your memories sorted and stored, so you can enjoy them! Do not let your photos and memory cards pile up again.

To keep this from happening, you will want to set some rules for yourself.

Film Photography

If you use a camera with film, remember to develop rolls as you complete them. You do not want to start a collection of film canisters and eventually forget what you've taken. Also, make sure to write down the stories right away and keep them with the photos. Put the undeveloped rolls where you can easily find them when you are ready to go to the store (or together in an envelope if you send them out to be processed). You may want to get in the habit of getting an additional disc of digital photo files for each roll you develop. (If you get digital discs, also maintain them by reviewing the information in chapter 6).

Once you receive your pictures, make it a habit to look through the pictures right away. Toss pictures you do not need or want to keep – blurry, accidents, and duplicates.

Once you've completed removing and sorting, put the pictures, negatives and discs away, so you can quickly find them the next time you go looking.

If you have not created a storage system, go to chapter 6 for assistance. If you need help with sorting, go back to chapter 4.

Digital Photography

Make a rule to work on your photos weekly, monthly, or after each big event. You will download pictures from your camera, review them, sort, write about and store them.

As you take pictures on a digital camera, get into the habit of immediately deleting blurry, accidental and identical photos. Keep only the best pictures on your camera: the ones you love and want to keep. Then you will not have as many to go through when you do your regular maintenance / download.

When you download from your camera, make sure you set enough time aside to do the following:

- Sort them into the proper piles (system already set up in the sorting section of this book).

- Backup files right away, so your memories will not be lost in case of computer crashes or other disasters. (Always have at least two copies of your digital photo files)

- If you are planning to print some of the pictures, prepare to print right away (even if you are not able to send them to print right now).

ের্ছ ের্ছ ের্ছ ের্ছ ের্ছ ের্ছ ের্ছ ের্ছ

For printing, I suggest having a regular plan for what to do with pictures you want to print. You can plan to print them right away, so

you do not have to worry about them, or you can save them for when you have a larger number to print.

If you are looking to print a number of pictures together, you can:

- Put them into a directory with all the other pictures you wish to print soon,

- Add them to a disc or USB flash drive with the other pictures you wish to print soon,[3]

 or

- Upload them to your online photo service right away, and add them to your shopping cart for when you are ready to print.

[3] A rewriteable disc is one way of making a disc of images to print. After the digital photo images have been printed, remove them from the disc and add new ones to print.

Can I tell you a secret now that you have gotten to this final step? I have a really difficult time following my own advice. There are feelings attached to the people in the photos, making it harder to let some go. I also think it may be partly because I grew up with film cameras. You had to keep everything back then. Now you do not need to print or keep everything and yet, I have a difficult time deleting all those extra pictures. Here's an example. I know – I'm going to decide which of these is best and only keep that one. I know I will save myself so much time and energy later!

Oh, but how to decide???? Trust me, this is a learned thing. If I can learn it, so can you!

8: MEMORABILIA EXAMPLES

"Been there, done that, got the T-shirt"

Up until now, mainly flat memorabilia and photos have been covered.

The problem is what to do with all the other memory triggers. Many of us feel that we cannot let go of special objects because it might mean losing of the memory or a connection to the person who gave it to us. This book is meant to be a guide to help you organize the things that help define you and that are still special to you.

My goal is also to help you determine what you should keep, and what you are ready to let go of. By letting go of something that does not give you joy or define you anymore, does not mean that you've lost the memory or that part of yourself. A physical reminder is not always necessary. If you do not have a photo or object to remember special events, it does not reduce your love or appreciation for that memory. Also, what good are memory triggers that you keep, but never look at?

> What good are memory triggers that you keep, but never look at?

When we think of memories, we usually think of pictures, but there are many other items that can also hold great memories. There are things that are special that you would want to display and enjoy. This may include trophies, school projects (anything from small paper drawings to 3-D science projects), T-shirts, wedding dress, collectibles, etc.

This chapter gives you a few ideas of ways of preserving and enjoying these items beyond the usual – T-shirt: wearing it. There are a lot of possibilities, and I could easily make an entire book just on this. You can probably find several fun crafty ideas on the Internet, too.

Here are ways to enjoy your memories without having them take over your life and home...

Artwork and Children's Schoolwork

Children love to see their work displayed. You can use the fridge (as many have over the years), or try one of these other ideas.

- Use a cork board where the latest work is displayed.
- Use a rope or ribbon that hangs projects from clothespins.
- The inside of a cupboard is a fun spot, because it doesn't make the kitchen look cluttered, yet allows you to enjoy the art every time the door is opened.
- Temporary or permanent hooks and clips can hang the latest and greatest work on the wall.
- Use an inexpensive frame to display your favorite prints. Remember to rotate images as new pieces come home.

Consider taking a picture of those 3-D art projects, children's artwork and other items you're hanging onto and haven't been ready to let go of.

Every month, I lay my children's schoolwork out on the floor and take a picture of it. This way, we can look back and reminisce about what they've done without having piles of papers everywhere. We only keep a few of our favorites. The rest are recycled.

End of the year awards laid out with the proud recipient.

I also keep one storage box for each of my children. They are in charge of their own papers and art projects. When the box gets too full, it's time to re-evaluate what's really important.

Since we're talking about children's art, an area that can be difficult with wanting to keep everything, here are a few other ideas to help you manage it.

When projects come in, decide right away if you want to save it or not. (You can also take the picture monthly as I mentioned above) Write on the back of the item what it is, date it came home, and the special meaning behind it. Maybe it's the first time your daughter wrote her name. Knowing this will mean so much more when looking back later. It will be important if you can let your child help with this. You might learn more about the history of the items yourself, and be less likely to toss something that they find extremely important. This could be a fun bonding experience.

If you do not like the idea of a storage box under the bed for your children's work, is there another type of container that you'd prefer? I have a number of parents who use new pizza boxes. They have one for each year of school. They are even fun to decorate with your child. You can include larger projects by taking a picture of them, if you don't want to fold them.

Expandable files work great for schoolwork, too. I purchased a 13-pocket expandable folder. Each year's important papers are kept

inside. This includes awards and the end-of-year report card. The best part of being 13 pockets? It will allow me to add every year from Kindergarten to 12th grade.

Trophies

Don't miss out on the great photo opportunities of your son or daughter holding the trophy they received. Remember to note how they earned it.

Trophies take up a lot of space! Be sure to take a picture that will keep that fun memory alive.

You can donate trophies to different organizations to help others. Search the Internet for local places to donate in your area. Special Olympics have been known to take trophy donations. Even if your trophy fell apart, it can be donated and used again as an award or as art.

Keep the engraved plaque, stating what the trophy was for. It can be kept in an album or frame next to the picture, and you can journal the story of how they received it.

A repurposed trophy: added a Nintendo Atari cartridge (spray painted gold) and a fun 80's sticker to present for the best 80's outfit.

Clothing

Are you holding onto special clothing? If taking a picture is not working for you, want to try a sewing project? If you don't sew, you

can find someone who does or find a business that specializes in this sort of thing. I recently made pillows out of some old T-shirts. The shirts were special to my father and made a fun gift for the person who has everything.

Many people hold onto their children's baby clothes. They can be really difficult to part with, even if you aren't planning to have more children. How about turning them into a quilt? You can also do a shadow box of a few favorite pieces with your child's picture wearing the items next to them.

Special jacket or shirt? It can be framed, too. You can even frame your Grandma's old doilies that she spent hours crocheting or tatting.

Ceramic and Kitchen Items

Have you had a difficult time parting with a beloved chipped dish that you are not using? How about turning it into a mosaic furniture item? Not already broken? You can break one and donate the rest of the set.

Could you keep just one dish, mug or cup from the set? You can repurpose them. An old glass or mug works great on a desk for holding pens and pencils. You could also turn an old dish into a soap or candy dish.

Does one piece mean a lot to you? A picture can be made into paintings at online photo stores. Imagine a photo of Grandma's favorite sugar bowl or teapot turned into art, framed and hung on your kitchen wall. You can also share family history and make multiple copies for everyone to enjoy. Since only one person can own Grandma's favorite dish, this might be a good gift idea.

Posters

Have a special poster? You can frame it! I was a theatre major in college and was in a number of plays in school and after graduating. I took a post from one event I participated in, along with tickets and pictures from the event. It looks amazing framed all together.

Family Videos

Old family videos? Transfer them to DVD. They'll take up less space, and will be easier to access.

You can have a local business transfer them, or purchase a machine to do it yourself.

Turn Pictures into Usable Pieces

You can turn pictures and other memorabilia into items like mugs, calendars, quilts, and mouse pads. Check out your local store or online. There are so many options to choose from depending on your interest and the memories you'd like to keep.

Collections

It's fine to keep a few items in a collection. Just don't let your collection take over your life. If you find it becoming too large to enjoy, or you do not enjoy it any more, weed down what you have. Consider selling or donating the items.

> "Do you own your collection, or does it own you?"
> Joetta Tucker (Professional Organizer)

Example:

When I was 13, I received a decorative mug from my aunt and uncle. It was really special because of the timing, design of the mug and who it was from.

This mug started a mug collection which I continued to add to for the next fifteen years. I had lots of special mugs. There were ones from my best friend, special trips, etc.

After some time, I realized that the mugs did not mean as much to me anymore. They were just collecting dust and taking up space. I managed to wean down the collection to two favorites which I promised myself I would use. In the past, my collection just sat on a shelf.

I donated each mug and still hold the special feelings from those who gave them to me. I do not need the collection to remind me of the

love or other joyful feelings.

My mug collection before beginning to donate pieces.

Greeting Cards

Many of us love to hold onto special greeting cards. This can be another sensitive area for us. Do the best you can just to keep the ones that mean the most to you and recycle the rest. There are organizations which will take old greeting cards for you, and turn them into new cards.

If you are looking for a home for your cards, there's a card book from Card Memories and can be found at www.cardmemories.com. If you like to display them, how about using decorative boards or paperclip style card holders? Just display the best and store the rest. You can change them out depending on your mood or season, too.

❧❦ ❧❦ ❧❦ ❧❦ ❧❦ ❧❦ ❧❦ ❧❦

Remember, as you go through what you have and think about what you want to keep, you do not have to keep everything! In fact, your collections will mean a lot more if you just keep a few special pieces. This holds true for pictures, children's artwork, old clothing, and your collections.

If something is not special to you any longer, or is not your style anymore, it's okay to part with it.

Do not let the money spent deter you. The money has already been spent and hopefully the time you had with it was enough for the cost. If not, then you will have learned to think twice before spending your money on something like this again.

Do not let the fact that it was a gift deter you. The special part of gift giving is the moment the recipient opens the gift. You've loved the item (even if just for a short time) and appreciate the sentiment. It's okay to move on. If you could hold onto everything you've ever received, how would you live in your home? I'm guessing there would be little room left for you.

I hope this gets you thinking about the best ways to handle the material things you treasure in life.

APPENDIX:

UNDERSTANDING DIGITAL PHOTOGRAPHY

"I used to have a photographic memory, but it was never developed." ~ Anonymous

Many people have questions about their digital cameras and not everyone owns a computer. Even without a computer, you can use and enjoy a digital camera[4].

Film and digital cameras look the same in many ways, but there are a number of differences which are helpful to know and to understand. You will have a better idea what you can do to make your pictures even better.

Digital Photo File Location

One of the main differences is where the digital photo images are stored. For film cameras, you have to purchase film. It's a one-time

[4] You do not need a specific "camera" in order to take digital pictures. I will use the term camera for all of those devices which will take digital images. You can now take pictures on your phone, MP3 (music) player, Personal Data Device (PDA), etc...

only use product which you complete before you are able to get your entire roll developed (if you want to get the full use of the film). Then you could pay to see if the pictures turned out okay or not. With a digital camera, you can see right away how the pictures turned out and even print them as soon as they're taken.

Digital cameras use memory cards or internal memory instead of film. Memory cards come in many different capacities, and store digital photo files electronically. Memory cards are reusable. You can also print as many or as few images as you'd like soon after you take the picture. You do not have to fill the card up completely in order to print images on it.

With film, you are much more likely to limit the number of pictures you take because you know it will cost money to purchase the film and have it developed. It's great that you have more freedom with digital to take as many pictures as you want. Unfortunately, this also means more digital photo images to figure out what to do with. How do you store them all? Do you need to keep them all?

Take the Best Pictures

If you want to take the best pictures, you need to play with your camera. Experiment with all the different features before you need them. Take lots of pictures without spending any money, so you feel comfortable with the camera; you do not have to print any of them. The next time you want to take a picture of little Johnny playing soccer, you will know the best way to take the picture. You want to know before you need it, so you are not scrambling at the moment you need it. If you wait, it may be too late to experiment. The time you spend becoming acquainted with your camera can make the difference between a moment captured and a moment lost.

> The time you spend becoming acquainted with your camera can make the difference between a moment captured and a moment lost.

If you feel like you need assistance, read your manual and/or

take a continuing education class, offered at many high schools and camera stores.

Shutter Lag

When you use a digital camera, you may have noticed that when you press the shutter release button to take a picture, it takes a little while to actually get the picture to complete. After experimenting, you may find yourself pressing the picture shutter release button before you say "3". Maybe you're getting a picture of when people are done smiling. Why is that? We did not have to deal with Shutter lag[5] when we had film cameras!

When you take a picture with a film camera, you press the shutter release button, light enters through the lens and the image is captured on one frame of film with minimal delay.

When you take a picture using a digital camera, you press the shutter release button, light enters through the lens, and it strikes millions of tiny light sensors–charge-coupled device (CCD). CCDs take longer to activate when the shutter release is pressed.

Luckily, as digital cameras continue to evolve, the shutter lag is becoming less and less of an issue. But in the mean time, here are some tips and tricks to help you keep shutter lag from ruining important moments.

Pre-focus the shot: When you know that a perfect picture is about to happen, first focus the shot by pressing half-way down on the shutter release button. Practice this before you need it, so you get the hang of it. It's easy to press too hard and take a picture when you just wanted to pre-focus the shot. When the images are ready for you, press down the rest of the way to complete the picture. This is great for moments when you know you are about to get the perfect picture. Examples include blowing out the candles on a cake or receiving an award. You are able to prepare for it.

Adjust shutter speed: Your camera may offer a setting to help

[5] Shutter lag: delay between the time the camera shutter opens and the moment the image is fully captured.

with shutter lag. Look for the following settings in your camera's manual: "aperture setting," "F-stop," or "shutter priority." Some cameras also have an "action setting" which uses a faster shutter speed.

Multi-shot mode: Some cameras offer a multi-shot or rapid-free setting. The camera focuses once and allows for multiple shots at the same setting before saving the pictures to memory.

Memory Cards: In some cases, it may be the memory card which is causing the shutter lag. If you find your camera taking a long time between pictures, writing to the memory card, you may want to consider purchasing a newer card. Most camera stores, which specialize in digital cameras, can help you decide what will work best for your specific needs.

Film Camera	Digital Camera
Uses Film • One time use • Print after roll finished • Print *all* the images (Can turn those images into digital photo files at many stores) • Typically come in 12, 24 and 36 exposure sizes	Uses Memory Cards (or internal memory) • Multiple uses • Print images any time • Print as many or as few digital photo images as wish • Hundreds of images can be stored on one memory card – depending on size of files and memory card
When you press the shutter release button to take a picture: • Light enters through lens • Image captured on one frame of film • Minimal delay • Image written to film	When you press the shutter release button to take a picture: • Light enters through lens • Strikes CCDs • CCDs take longer to activate • Memory cards store images

Pixels

In order to understand how your camera works and why your pictures may or may not be turning out the way you want them, you need to know what a pixel is.

Pixels are the building blocks of digital photo image and represent small colored points of light. Pixels are mostly square in shape. Together in large numbers, they bring a photo to life.

Resolution

Resolution is related to the number of pixels that make up a digital photo image.

The best way I've found to explain resolution is to have you picture a room (the room you are in will be fine as long as it's rectangular in shape). In this room, you can fit a set number of the same sized boxes. You can think of these as square feet, but those boxes can change in size. In the below example, this room is 8 boxes by 8 boxes:

If you change the size of the room, but keep the same number of boxes, the size of each box will also change.

Still 8 boxes by 8 boxes

For the best resolution, you want the boxes to be small.

Here's an example of the difference between higher and lower resolution images. This digital photo image is 4,288 x 3,216 pixels in size.

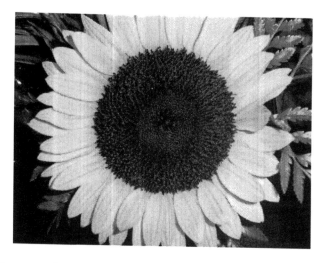

Compare this to a lower resolution picture (below) which is only 96 x 72 pixels. Can you see the difference?

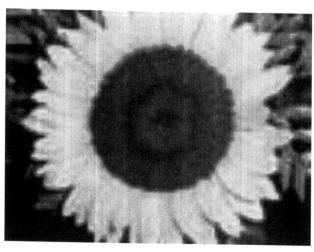

But if you make the picture smaller, it will not be as blurry or boxy because the pixels are now smaller (still the same number of pixels as the second photo, but these are each taking up a smaller space).

Like in our room example, resolution is the total area/number of pixels that make up a digital photo image.

Example: this "image" is 8 boxes x 8 boxes = 64 total boxes (which we'll call pixels for this example):

No matter how large or small you make the overall room, it always has an area of 64 pixels.

How does this relate to your camera and your digital photo images? If you have a digital photo image like the first sunflower picture which is 4,288 x 3,216 pixels, you would get an area of a total of 13,790,208 pixels. To make this number make more sense, we change it into megapixels. 1 megapixel equals 1,000,000 pixels. The example above for 13,790,208 pixels is the same as writing 13.8 megapixels (I rounded off the extra numbers).

Digital cameras are labeled according to their maximum resolution value. For the example digital photo image which is 13.8 megapixels, it came from a camera labeled for 14 megapixels.

Why is all this important? You probably want to be able to print or view your digital photo images.

It doesn't make too much of a difference in clarity if our pixels are really small. When they begin to get bigger, the digital photo image becomes blurry. And in some cases, you can tell that the pixels are boxes because they're too big to blend together seamlessly.

When our cameras have a large number of megapixels, it may seem pointless to worry about the issue of low resolution digital photo images.

Have you ever tried to zoom in or crop an image, so you eliminated part of the image and focused only on another part? You will begin to cut down the number of pixels which make up the digital photo image and thus make it difficult to create a quality print in the future.

Here's an example as I blow up the previous picture even more:

Zoom

Not all zooms are created equal.

In the past, digital zoom was a popular zoom. It's now being eliminated in many new cameras. If you only have an optical zoom, you can skip this section all together. If you have a digital zoom, read on.

Optical zoom uses the glass lens to get a closer picture of what you are zooming in on. When you use the optical zoom, the camera

[6] This picture was cropped from the lower resolution picture shared earlier – it's now 166 x 125 pixels in size – notice how blurry and boxy it looks.

is capturing the full quantity of pixels for a good resolution print.

Digital zoom selects and enlarges only a <u>portion</u> of the image area when it enlarges. In other words, it captures fewer pixels causing a fuzzier digital photo image: lower resolution.

If you have a digital zoom, I recommend not using it. Some cameras may give you the option of turning it off. On others, there may be a feature which lets you know when optical zoom ends and digital zoom begins. On one of my cameras, the color of the zoom bar would change once I passed into the digital zoom.

> If you have a digital zoom, I recommend not using it.

If you want your picture to be closer, you can crop it later and have a better quality image.

True Digital Print Size

Have you noticed that when you print your digital photo images as a 4x6 print that part of the top and bottom of the image has been cut off? Maybe you've been asked if you want to convert the 4x6 images to "True Digital," "true digital size," 4x5.33, "4XD" or something similar.

The way that 35mm cameras take pictures, the dimensions are such that a 4x6 print could be easily created from the image. If you recall, some of the older films created different sized prints. Kodak's Disc camera took an almost square image of 3 ½ inches. My first camera was a 110, and it took pictures of about 3 ½ x 4 ½ inches in size.

We're used to receiving 4x6 prints, which is why most stores offer this size. However, most digital cameras save their digital photo images in a size which does not work well for a perfect 4x6 print.

The relationship between the height and width of the 35mm film image makes a perfect 4x6 image (Its aspect ratio is 3:2).

Many digital cameras take pictures in a different aspect ratio: 4:3.

What does this mean when you go to print a 4x6 print? Part of the captured digital image will be lost. Here's an example using our sunflower picture again. The shaded areas on the top and bottom would be removed to create a 4x6 print.

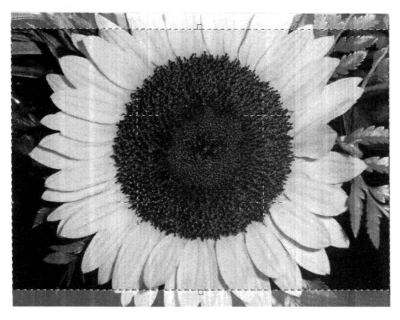

If printed in its proper "true digital" size, it will print as a 4 x 5.3 image.

Some digital cameras offer 3:2 ratio or will allow you to choose your own ratio. You can also use photo enhancing software to crop your digital photo images to assure you get what you want in your printed picture.

This explains 4x6 prints. We have other common sized prints including 5x7 and 8x10. If you were to do the math, you will notice that 3:2 aspect ratio does not fit. The 4:3 ratio also does not fit. These are different and will result again in cropping of your digital photo image – either by yourself or the printing service you are using.

The next page shows our sunflower again as a 5x7 cropped digital photo image (7:5 aspect ratio). Can you see how the digital photo image is closer to this ratio as less is cropped from the top and

bottom of the original digital photo image?

Here's our sunflower for an 8x10 image (5:4 aspect ratio). This time it is cropped on the other sides of the image:

Now that you understand picture ratios, you can be sure to get the true picture you want printed.

GLOSSARY

Aperture	Aperture has to do with how large the lens opening is when taking a picture. More light will enter through the lens as the opening gets bigger.
	Aperture is measured in f-stops.
Burn a CD	Expression used to mean that files have been transferred to a CD.
Download	When working with information on the Internet, also referred to as online, when information is moved from the Internet to your computer, it is said to be "downloaded."
	This also refers to moving your digital photo files from your camera's memory card to your computer.
	The opposite of download is upload.
Dry Lab	Refers to the way in which pictures are developed in a store.
	The basic difference between this and the previous labs, which processed film, is that when film is processed, it goes through a number of steps which include moisture and a

drying process. With a dry lab, there are no wetting/moistening steps to the developing which is why they call it a "dry" lab.

The main reason for this change is that it's less expensive to have a dry lab, so stores and other locations can afford them.

Dye-sublimation Photo Printer

Think of each photo print like a sandwich. The printer paper is on the bottom, like the bread. On top of the paper, layers of color are printed. The colors used are Cyan, Magenta, and Yellow. For each photo print, the printer will transfer each color separately onto the printer paper using heat.

Once the color is transferred to the print, the print then runs through the printer one last time to add the overcoating (the top piece of bread). The overcoating adds a thin laminate which protects the print from light and moisture.

Once a print is made, the colors cannot be used again. It would be like trying to use transfer paper on new sheets of paper. After awhile, there will be gaps where it won't write because it's already been rubbed off onto another sheet.

F-Stops

Aperture is measured in f-stops.

See Aperture

Jump Drives

See USB Flash Drive

Keychain Drive

See USB Flash Drive

Memory Card

You can learn more about memory cards in the appendix. You'll learn more about digital cameras and their digital photo images.

Memory cards are used by digital cameras. Each holds a limited amount of information expressed in MB (megabytes) or GB (gigabytes). The type of memory card used will depend on the camera you own. Your camera's manual will tell you what to use.

Some cards can be used in many different

devices and some are proprietary (only used in that specific camera or device).

Memory Sticks *See* USB Flash Drive

PAT *See* Photographic Activity Test

Photographic Photographic Activity Test (PAT) is a number
 Activity Test of tests performed on products to be used with printed photographs including paper and ink. If a product passes the test, you know it will be safe to use with your photos. You may also see it defined as ISO 18916:2007.

The International Organization for Standardization has standardized tests, so you can trust the quality of products which have passed.

Shutter Lag Shutter lag is the delay between the time the camera shutter opens and the moment the digital photo image is fully captured.

Shutter Priority Shutter priority is a setting on some cameras which allows the user to choose the shutter speed.

Social Media Internet sites like Facebook, Twitter and My Space. There are many of these, and they will change and grow as time goes on.

Thumb Drive *See* USB Flash Drive

Upload As opposed to download, this is when data is moved from your computer to the Internet.

When you're placing digital photo files on a website for others to view, you are uploading.

USB Flash Drive There are many different terms used to describe these. I will use "USB flash drive," to keep it consistent.

These are removable drives which fit in your computer's USB port, making sharing so much easier. They're a great way of storing a lot of information in a small space.

You may have heard: USB drives (because they fit into the USB port of your computer), flash

101

drives (they use flash memory), USB flash drives, memory sticks, jump drives (because you can quickly jump between computers with these drives), keychain drive (many people keep on their key chains), or thumb drive (because it's about the size of your thumb).

INDEX

photo organizing, 36-43, 65

sort, 5, 9, 10, 12-13, 14-15, 18-19,
20-47, 48-49, 77

store, 9, 18-19, 22, 35-47, 52-75,
78, 86

T

trophy, 83

true digital, 96-97

U

upload, 78, 99, 101

USB flash drive, 18, 33, 70, 72, 101

V

video, family, 85

W

write, 3-4, 7-8, 15-16, 30-31, 32, 40-
41, 46, 48-51, 64, 66-67, 76, 77,
82, 83

Z

zoom, 95

digital, 95-96

optical, 95- 96

See cropping

ABOUT THE AUTHOR

Gretchen M. Fatouros is a Professional Organizer and founder of: From Clutter to WOW! She is a member of the National Association of Professional Organizers (NAPO).

She lives in Rochester, NY with her husband, two boys, and two cats.

With roots in the Rochester, NY area, the backyard of Kodak, it's difficult not to be interested in photography and memories.

Visit the website at: www.FromClutterToWOW.com

From Clutter

to WOW!

Let's start NOW!

Helping busy people find more time for the things that matter.[SM]

www.FromClutterToWOW.com

Quick Order Form

Email Orders: Gretchen@FromClutterToWOW.com

Internet Orders: www.Amazon.com;
Look for ISBN: 1466316489

Postal Orders: From Clutter to WOW!, Gretchen Fatouros,
P.O. Box 426; Churchville, NY 14428, USA.

Phone orders: 585-794-6442 (please do not leave credit card
information on voice mail: Name, phone number and reason for call)

Please send the following books:

It's All About the Memories at $10.95* x _____ (quantity)

Subtotal: _____

Shipping and handling fees: _____
$5 first book and $2 each additional book

Subtotal: _____

8% tax in NY State: _____

Total Due: _____
(Please make check or money order out to:
From Clutter to WOW!)

Name: _____

Address: _____

City: _____ State: _____ Zip: _____

Telephone: _____

Email address: _____

Thank you for your order!

* Prices in U.S. dollars

From Clutter to WOW!

Let's start NOW!

Helping busy people find more time for the things that matter.℠

www.FromClutterToWOW.com

Quick Order Form

Email Orders: Gretchen@FromClutterToWOW.com

Internet Orders: www.Amazon.com;
Look for ISBN: 1466316489

Postal Orders: From Clutter to WOW!, Gretchen Fatouros,
P.O. Box 426; Churchville, NY 14428, USA.

Phone orders: 585-794-6442 (please do not leave credit card
information on voice mail: Name, phone number and reason for call)

Please send the following books:

It's All About the Memories at $10.95* x _____ (quantity)

Subtotal: _____

Shipping and handling fees: _____
$5 first book and $2 each additional book

Subtotal: _____

8% tax in NY State: _____

Total Due: _____
(Please make check or money order out to:
From Clutter to WOW!)

Name: _____

Address: _____

City: _____ State: _____ Zip: _____

Telephone: _____

Email address: _____

Thank you for your order!

* Prices in U.S. dollars

Made in the USA
Lexington, KY
07 January 2012